Masterpieces of

Michelangelo & Milton

(1896)

ISBN-13 : 978-1512352337
ISBN-10 : 1512352330

Copyright©2012-2014 Iacob Adrian
All Rights Reserved.

Notice

This documentary study use historic, archived documents.

Because of this, some pages may look blurry or low quality.

Still are included in this book because they have

high value from critical, documentary, historical,

informative and journalistic point of view .

Dtp and visual art

Iacob Adrian

THE MASTERPIECES

OF

MICHELANGELO AND MILTON

BY

ALEXANDER S. TWOMBLY

ILLUSTRATED

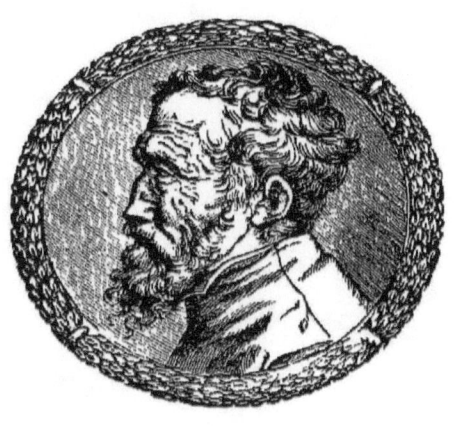

Author statement

This is a series of art books.

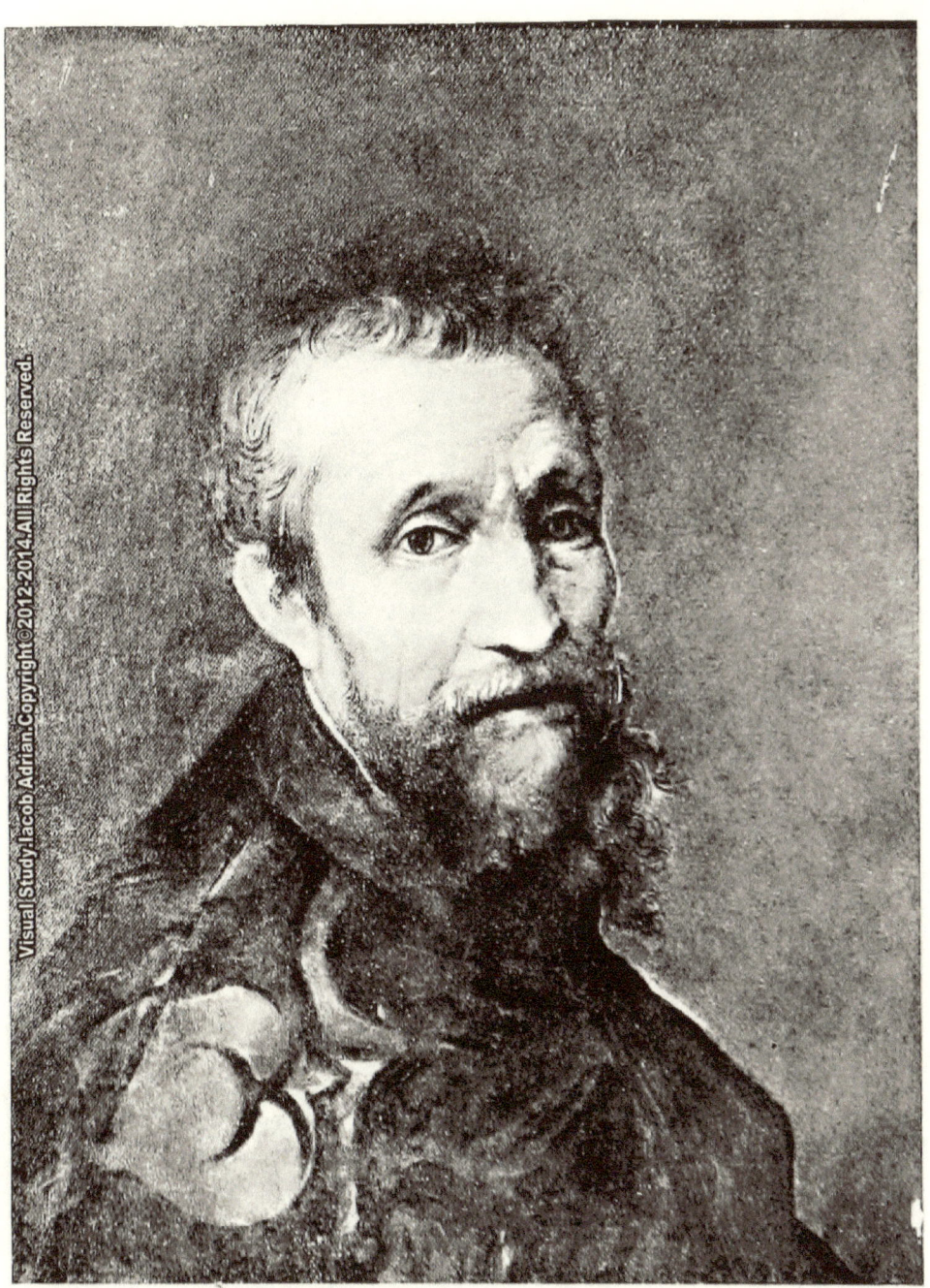

This little Book conveys the greetings of

..

to

..

MICHELANGELO AND MILTON.

In genius they are akin. Milton wrote his Epic in verses that will never die; Michelangelo wrought out his, in immortal works.

Both deal in colossal figures, and in grandeur of conception they are one. Had they changed places and epochs, Milton would have been, as the great artist was, a defender of liberty and a mighty prophet of judgment. Michelangelo would have celebrated Cromwell and his Ironsides in Art, with the vigor of a Puritan, and would have given immortality to the Regicides in imperishable marble.

Milton's Il Penseroso is matched by some of the more somber sonnets of Michelangelo, and both have interpreted to men the deeper things of God. Milton, in his blindness, drew light for the world from the inner revelation of Divine Truth, and Michelangelo, in his isolation from men, communed with the Infinite.

They fittingly belong together, although differing in attributes, and the Sistine creations of the painter may well illustrate, as they do in this book, the masterful inspirations of the writer of Paradise Lost.

Notes

TABLE OF CONTENTS.

PART FIRST.

MICHELANGELO.

	PAGE
LA PIETÀ AND THE DAVID. EARLIER WORKS	15
THE MOSES. FIRST GREAT MASTERPIECE	35
CEILING OF THE SISTINE CHAPEL	45
TOMBS OF THE MEDICI. NIGHT AND DAY. TWILIGHT AND DAWN	56
THE LAST JUDGMENT. SISTINE CHAPEL	73

PART SECOND.

MILTON.

PREFATORY NOTE	95
THE POET AND THE POEM. PARADISE LOST	99
MILTONIC CONCEPTION OF SUPERNATURAL BEINGS . . .	107
MILTONIC THEORY OF THE LIFE OF MORTALS	127
SPECIAL STUDY OF MILTON'S EVE	156

Notes

LIST OF ILLUSTRATIONS.

PART FIRST.

		PAGE
MICHELANGELO	Portrait, by himself	*Frontispiece*
MASQUE OF SATYR	The Bargello, Florence	21
LA PIETÀ	St. Peter's, Rome	29
THE DAVID	Florence	33
THE MOSES	Rome	39
ZACHERIAS	Sistine Ceiling	49
LIBYAN SIBYL	Sistine Ceiling	53
TWILIGHT AND DAWN	Sacristy, Florence	65
NIGHT AND DAY	Sacristy, Florence	69
THE LAST JUDGMENT	Sistine Chapel	81
ST. PETER'S	Rome	89

PART SECOND.

MILTON	Portrait, A.D. 1670	93
THE CREATION OF ADAM	Michelangelo	103
SATAN	Wiertz, Bruxelles	113
CHRIST AS A JUDGE	Michelangelo	117
THE TEMPTATION AND EXPULSION	Michelangelo	133
THE CREATION OF EVE	Michelangelo	157

Notes

Part First.

MICHELANGELO.

"When Nature made him
She broke the mold." — *Ariosto*.

MICHELANGELO.

THE EPIC MEANING OF HIS MASTERPIECES.

I.

LA PIETÀ AND THE DAVID.

It is not our purpose at this time "to drag the lumber of the schools through the garden of the muses," or to relate all the events which belong to the great artist's life and times.

We shall simply attempt to show the epic meaning of Michelangelo's greatest masterpieces, as a study of the higher motive in his career and character. The works which we consider the greatest and the best adapted to our purpose, are four in number: viz. The Moses, in the Church of San Pietro in Vinculi at Rome; the frescoes of the ceiling of the Sistine Chapel, in the Vatican; the four recumbent statues, Night and Day, Twilight and Dawn, in the Sacristy of the Church of San Lorenzo at Florence, and The Last Judgment, on the wall of the Sistine Chapel.

These works mark four distinct periods in Michelangelo's life, and represent the noteworthy characteristics of his thought and action.

He was always a peculiar being; he never had a mother's care; as a boy he was wild, erratic, imaginative, and the idiosyncrasies of his maturity were the natural outgrowth of the peculiarities of his youth. The only change in him as he grew older was that he became more caustic, exclusive, and impetuous.

None of the sweet felicities of mist and twilight, surrounding the towers and heights of Florence with a veil of beauty, softened the vigorous movement of his mind. None of that gleaming sunlight which gilds the Dome of Brunelleschi and the Campanile of Giotto imparted its chastened luster to his conceptions. It was Florence, magnificent in agony, sublime in civil convulsion, that seized upon his mature genius and hurled him, mallet in hand, upon the marble from which he drew forth the images of his soul's passion.

He worked his marble with his own hand. Many sculptors fashion their models only in the clay. He could see in the rough block the form he meant to bring out of it, and must hasten lest the ideal image vanish. There is no hesitancy; there can be none in the creative transport; every clip

tells; not a false stroke; delicate touches, but with a powerful hand; no rest till the form emerges; sleep is an enemy, food an interruption; he lies down at night in his clothes, to be ready at dawn; into an hour is put the intensity of a lifetime.

He appeared on the stage during an epoch which demanded this intensity in action and which produced men like Columbus, Luther, the Emperor Charles V., and Henry the Eighth.

Born of noble stock, with a crest which carried as a symbol two bulls' horns, full of hereditary impetuosity, he took into his heart all the trials, shames, and sorrows of his native land, and flung forth in impassioned works the feelings which overmastered him. These monuments, while they tell us of his superb ability, are also a revelation of their creator's inner life.

Had Michelangelo been a soldier, he would have been foremost in the midst of tumults and battles; a poet, he would have been like Dante, whom he studied and passionately admired; a reformer, with Luther he would have answered the anathemas of Popes and made them tremble at his name.

But as an artist, there is but one way: his art is his only channel for expression; his tempestuous spirit must free itself in the production of immortal works.

Great natures demand great movement, and the times in which he lived stimulated and developed his grandest powers. The old world was dying; the new bursting into flower. Printing was beginning to diffuse and popularize knowledge, hitherto the exclusive possession of the learned. The first book (Jenson's Decor Puellarum) was printed in Italy in 1461. Dante's Divina Comedia in 1472. America was discovered when Michelangelo was a youth of seventeen years; the Reformation, under Luther's leadership, began to change the political as well as the religious aspect of Europe, when he was at the zenith of his fame.

The Church of Rome, imperial, remorseless, inquisitorial, originated at this time and followed up with success the idea of enlarged temporal sovereignty; under the Borgias, the Medici, and the Farnese, it became diplomatic, intriguing, and warlike.

The fine arts likewise felt the new impulse. The old Roman architecture yielded to new modes of expression, subject to the forms of the ecclesiastical renaissance. Finally, the free cities and republics of Italy passed into the hands of tyrants; Florence itself, after heroic but fruitless struggles, submitted to its fate — oblivious of the past and careless of

the future — to become the prize of the strongest usurper.

It was, however, the good fortune of Michelangelo in his youth to live in Florence during its palmy days, before its liberties were lost, and there to receive an education, the best the world afforded at that time. To be sure, society was both cultivated and coarse, heroic yet brutal, materialistic yet superstitious. A strange environment, which nevertheless gathered influences about him that kindled enthusiasm, opened his mind, fitted it for observation, and gave it the broadest scope for its genius possible in that age.

The Italy of that period was the center of the trade, the luxury, and the art of the known world. All the nations were under tribute to this land of merchant princes. The Dark Ages gave up long-buried, ornamented manuscripts. The Popes began to unearth the statues of antiquity, and all that was finest in Italy flowed into Florence, under the enlightened though selfish policy of the Medici.

Cimabue had brought Byzantine art to Florence. Giotto had embellished the city. Lorenzo de' Medici had collected ancient marbles. Massive palaces, the Cathedral, the Baptistry, and the palace of the Signory, were already built, and stood, as in

our day, for Michelangelo to catch the inspiration of their solid grandeur.

Gems, carvings, iron filigree, abounded; the fables of Ovid were painted on the bedsteads and mantels of the princely houses; the artisans competed for prizes and were gratified by processions, pageants, masquerades, in the streets. In the *loggia*, or covered piazzas on the tops of the palaces, princely men and gay women looked down on the surging masses of the highways, or off towards beautiful Fiesole and the hill crowned by the Church of San Mineato. Ambassadors were received in regal state by the merchants, and treaties were negotiated.

Thus Florence at the height of its glory was the educator of the young sculptor, the history of Florence his text-book, its temples, galleries, and works of art his object lessons, and its applause the prize he sought. Any other city, even Rome itself, which contributed not a little to his artistic development, could not so well have furnished his mind in its adolescent stage.

It is true that the old Paganism was revived in these intellectual and luxurious tastes, but it is also true that the Christian element was not lacking. That masque of a satyr, on which Michelangelo exercised his youthful powers in the garden of San Marco, is a symbol of one side only

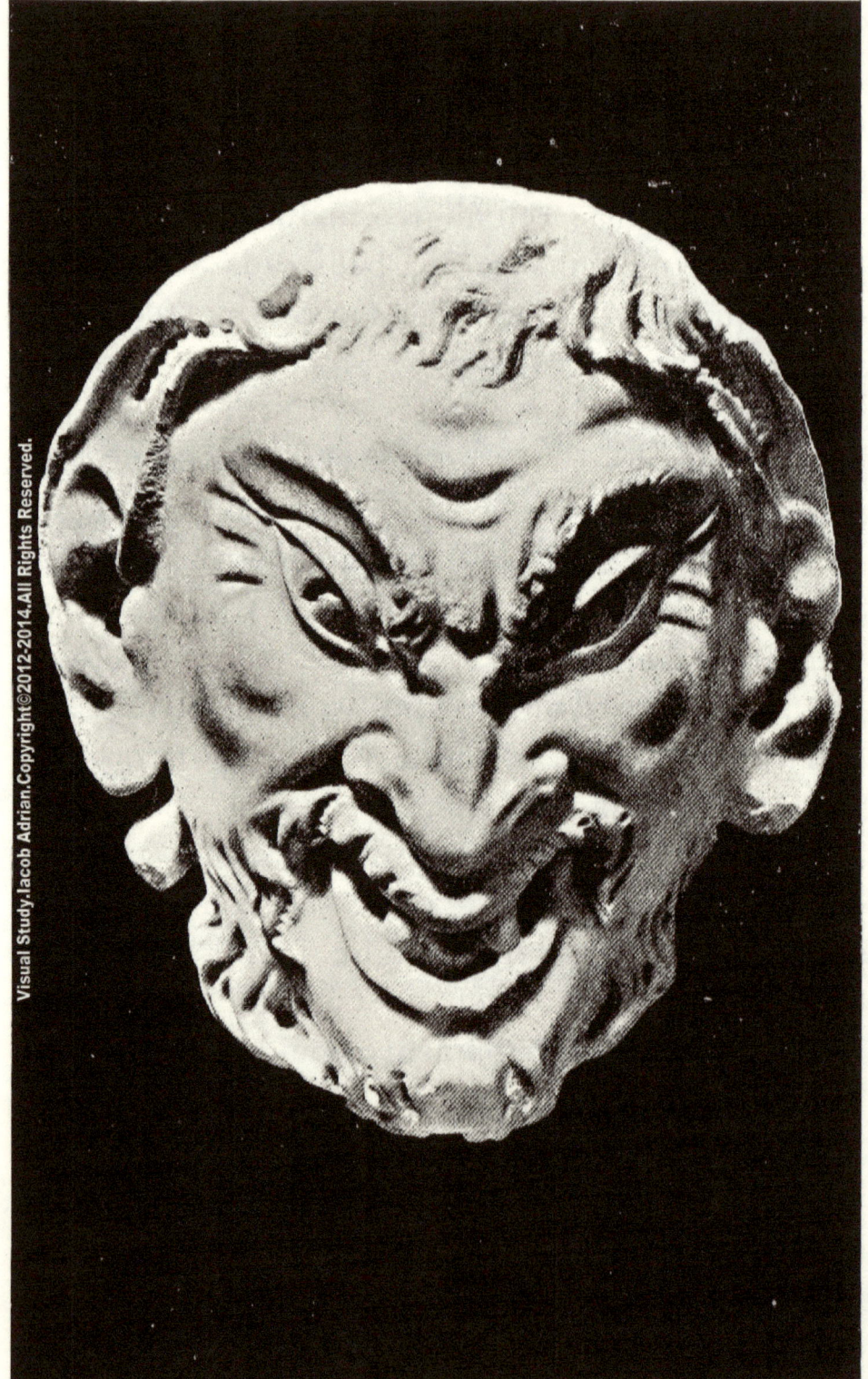

Notes

of the influence of Florence upon the exuberant imagination of his precocious young manhood.

His education was many-sided. His intelligence was stimulated by contact with the learned in the household of Lorenzo de' Medici, and his genius cultivated by contact with the best masters and their works.[1]

It remained, however, for the voice of a monk to awaken the slumbering soul of the artist to the perception of a spiritual ideal, which began the process that ended in the production of his most noble creations. He achieved some remarkable works in this early period, a Madonna, a Cupid, a Hercules, and a St. John; but as yet nothing commensurate with his great power had been produced.

It was Savonarola, the Prior of San Marco, the religious enthusiast, the reformer of religion and the State, who, coming to Florence when Michelangelo was barely of age, brought with him a new revelation to the artist's soul. The passionate discourses of the monk, during Lent in 1495, aroused the popular conscience, and the youthful artist at once became his willing and devoted adherent.

[1] Some contemporary painters: Giorgione, Dürer, Titian, Correggio, Perugino, Raffaelle, Da Vinci, Giulio Romano, Sebastian del Piombo, Hans Holbein, Paul Veronese, Tintoretto, Domenichino (1581–1641).

Not only did this fervent pleader implant seeds of religious truth deep in the susceptible soil of his heart, but he also burned in upon the nature of Michelangelo an intense love of liberty—for Savonarola sought to remodel the city politically as well as morally. This was his mistake as a preacher of righteousness, and it cost him his life; but none the less did he emancipate the whole being of one of the grandest men of the century from sordid aims and mean endeavor.

He opened to the sculptor the courts of the city of God, that he might become immortal in the works which even to-day satisfy our ideal of majesty and truth, and in which is embodied a mystic exaltation, which all who look upon and study them must feel.

Thus the dignity of Truth in Michelangelo's masterpieces is not only a gift to the world by their author, but is also a legacy from Savonarola to the ages. The great artist himself bears witness to this, in his statement that "the living word of Savonarola would always live in his soul."

It is by no means claimed that Michelangelo became a consecrated man, weaned from self and given to holy service. Religion in his day was busy with external ceremonials; it fostered material and gross conceptions, penance, and the tragic

element in Christ's sufferings, which blinded men to the holier ideals of love and sacrifice. Even in Savonarola's teachings there was an excess of zeal, which reacted on a mind like that of Michelangelo in its calmer moods, and could not give comfort in times of despondency.

When, therefore, the young Florentine, just coming of age, went from home to seek his fortune, and was carried into the great vortex of Rome, a city spiritually and ecclesiastically demoralized, we do not wonder that he yielded for a time to the seductions of ignoble ambition, and was in danger of being overcome by the almost wholly Pagan spirit in religion and in art, which prevailed under the very shadow of St. Peter's.

Alexander VI., of the shameless and cruel family of the Borgias, was Pope, and his son (called his "nephew") was the pugilist, Cæsar Borgia, who, fighting on horseback with a pike, slew with his own hand six savage bulls. There were also young Cardinals in Rome, who, clad in complete armor, galloped through the streets, and who sold at auction the gold and silver vessels of their churches for money to bribe their friends and foes.

And yet, standing amid the ruins of old temples, on the rock of the Capitol, in the churches and

the Vatican adorned with the paintings of Mantegna and Melozzo, Michelangelo seems to have forgotten that Lucrezia Borgia of infamous memory was the Pope's daughter, and that the vulture-wings of that debauched family were spread over all the churches, castles, and habitations of the most princely and luxurious city of the world. He gave himself up for a time to the fascinations of antique art, and his first work, executed at Rome for a Roman gentleman, was the statue of a drunken Bacchus. He also made a Cupid for the same patron.

But during the three years of his first visit to Rome, strange things were happening in Florence, from which news was received almost daily. He heard of the marvelous power which his beloved Prior was gaining over the people; how thousands of boys and girls gathered in the city to receive the sacrament, and how at the carnival a pyramid was raised in the square, of condemned luxuries—false braids of women's hair, costly garments, profane books (Petrarch and Ariosto among them)—and burned with cries of "Long live Christ, the King of Florence," and "Mary the Queen," while enthusiastic crowds danced around the pyre and sang religious songs,—a kind of Salvation Army of the fifteenth century.

He heard reports of the fiery Monk's invectives against corruption in morals, and his ardent appeals for a holy life; but he also heard how the bold preacher interfered with the government of the city, drove out the Medici, and established popular sovereignty. Then came the Monk's defiance of the Pope, the Pope's excommunication of the Monk and the fatal blunders in prophecy, which at last, in 1498, consigned the Reformer to the flames.

Gradually the young sculptor, under the influence of these tidings which revived his early feeling, recovered that higher conception of art, with which the Monk's teachings had at first inspired him, and suddenly, relinquishing his brilliant imitation of the antique, produced a different kind of work, which at once placed him among the most original and famous masters of religious art.

It was a group called La Pietà and represented the Virgin Mary with the dead Christ in her lap. The group stands to-day in a side chapel, on the right as one enters St. Peter's. Although the divine son seems older in death than the mother in her pure, virginal freshness, yet the whole group withdraws the mind from the contemplation of possible incongruity, and fills it with profound sympathy for the inconsolable Virgin, and rever-

ence for the divine form lying so heavy and helpless on her knees.

As this marvelous creation was finished about the time that Savonarola was burned at Florence, and as a revolution in popular feeling speedily followed the martyrdom (the martyr's picture, with a crown of glory around his head, being exposed for sale even in Rome itself), we cannot help believing that this sad ending of a life which was so dear to the young artist, had much to do with the obvious change which from this day forth took place in his thought and art.

Having been beguiled to linger in the groves of the Harpies, and to trifle for a while with the Pagan spirit which poisoned the atmosphere surrounding him, he now rises up, like his great prototype Dante, from the seductive temptation, and hearing the dying voice of Savonarola as Dante heard the voice of Beatrice from the Shades below, triumphs over the years to come — years in Florence, when it would have been riches to him to have served obsequiously his country's masters — and years in Rome, when even Popes would seek to seduce him to sacrifice his honor to their favor.

Before he came to Rome, he yielded to the suggestion of one of the Medici, that the Cupid

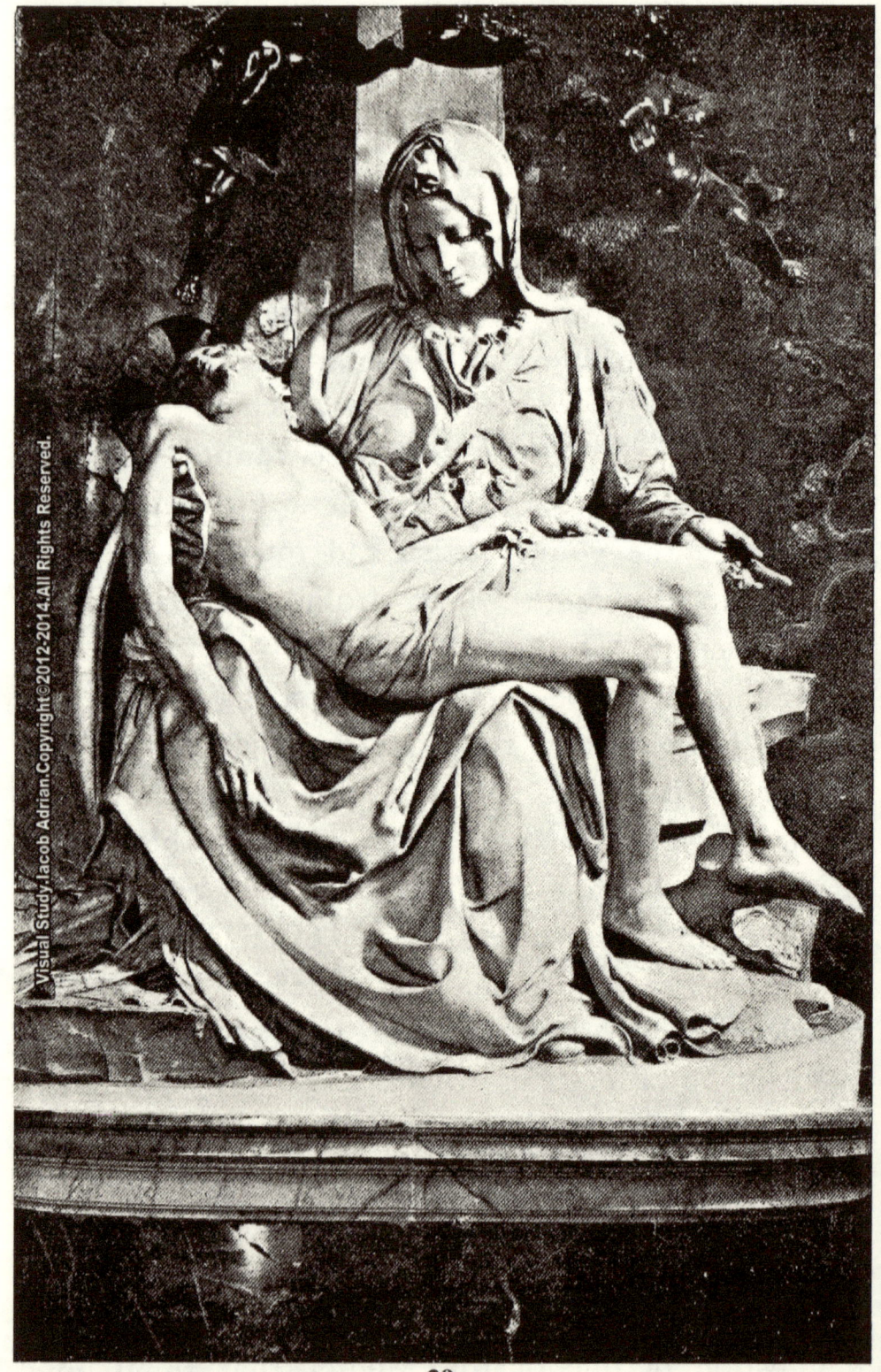

Notes

he had wrought should be stained to imitate the antique, and that a Roman Cardinal would give a princely sum for it. Woefully cheated in this affair by the agent, one Baldassare of Milan, he set out for Rome to recover his loss. When, however, he returned to Florence in 1499 or 1500, it was in a very different frame of mind and with far nobler purposes. Immediately he designed a life-size Madonna, and a Holy Family now in the Tribune at Florence. At once, Fortune began to smile upon him.

While engaged in these works, in 1501 a sudden calamity overwhelmed his native city. Cæsar Borgia, the Pope's son, demanded that the tyrannical Medici in exile should be restored, and so threatened the Florentines that they agreed to pay 36,000 florins if he would withdraw his troops. In spite, however, of this immense tribute, the art-loving city at this very time commissioned Michelangelo to undertake an important public work.

An immense block of awkwardly hewn marble had been lying unused in the courtyard of the workshops of the Cathedral. This block the citizens commissioned the sculptor to fashion into a colossal statue to be placed in the great square of the city. And thus, with great difficulties to

be confronted, owing to the malformation of the block, the masterpiece of the David was begun.

It was completed in January, 1504, and stood in its proud position before the ancient palace of the Signory until, in 1873, it was removed to the Accademia delle Belle Arti, that it might the better be preserved. Its completion, so near the time of the deliverance of Florence from her three most dangerous enemies, Alexander, Cæsar Borgia, and Piero de' Medici, may have suggested to the mind of its originator, even as it did to the minds of his countrymen, the personification of the still youthful vigor and splendid exaltation of the city of his fondest admiration.

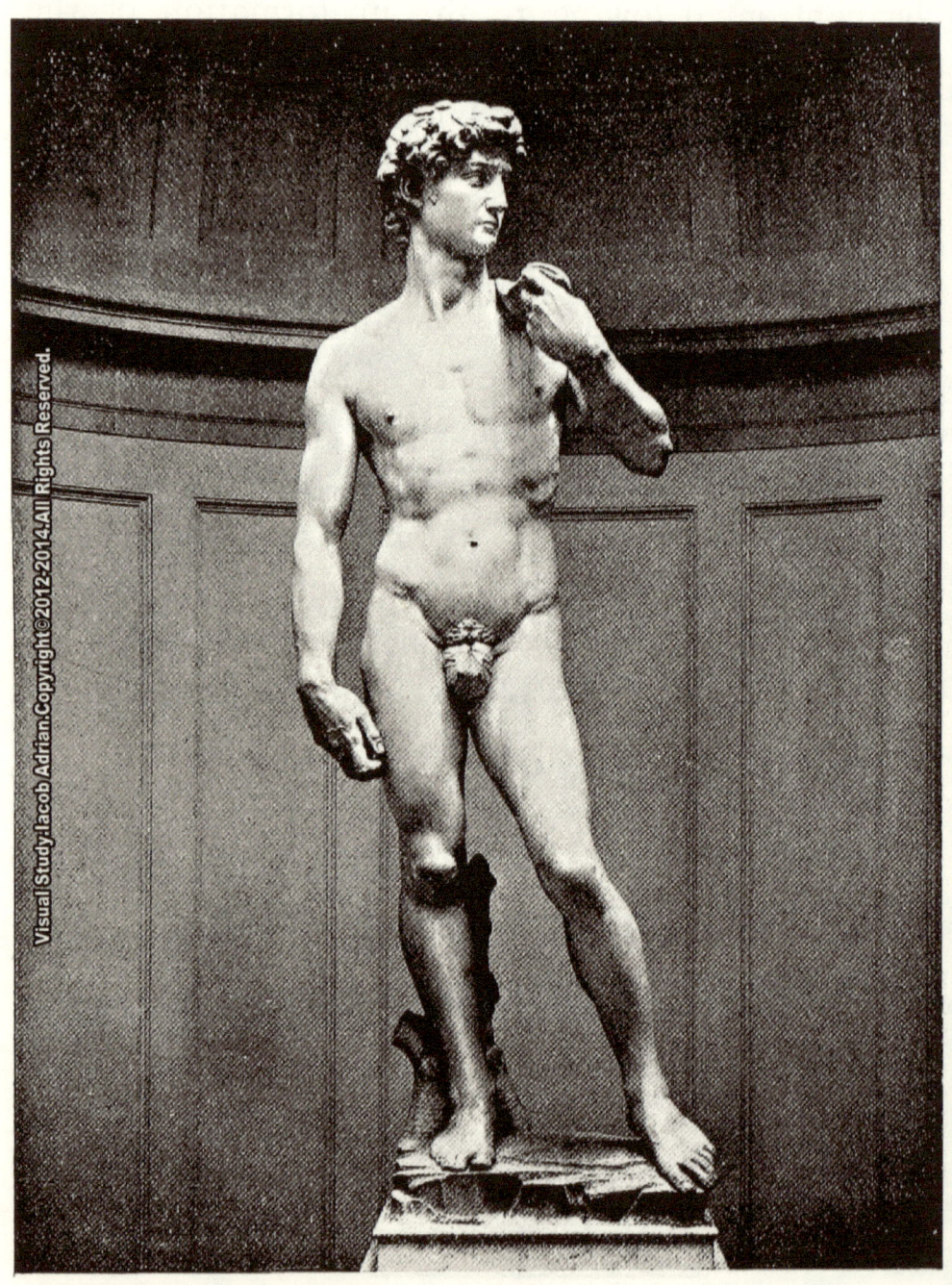

Notes

II.

THE MOSES.

We come now to a period in his history when Michelangelo's real masterpieces begin to appear. We say "begin to appear," because the Moses was a work on which he toiled at intervals for fifty years; the ceiling of the Sistine Chapel was not completed till 1511; the Sacristy of San Lorenzo with its sculptures was never finished, but was left in 1530 as it now is; and the Last Judgment, on the wall of the Sistine, was exhibited to the public in 1541, when the artist was sixty-six years of age.

As has been said already, these four are the sculptor's mightiest achievements. We do not add to them the architectural triumph which he won in the building of St. Peter's Dome, because that is so different in its demand on his genius as to deserve a careful treatment from another hand; and, moreover, it has no place in our present purpose. We shall confine ourselves therefore to the four masterpieces, in which the grand motive

of the artist's life, from this time onward, may be definitely traced.

Michelangelo is now thirty years of age and in the full maturity of his powers. He is again in Rome, called there by Pope Julius II., who, whatever his faults, was the noblest patron of the arts that ever wore the tiara, and the most sagacious of all the Popes in selecting artists of ability. His large projects are seen in the various orders given to the sculptor soon after his arrival. The Vatican is to be splendidly remodeled, and he commissions Michelangelo to build at once the most magnificent mausoleum ever planned by Christian or Pagan potentate. St. Peter's itself is to be rebuilt in order to receive it.

Michelangelo suggests a hundred thousand crowns as the expense; Julius exclaims "Two hundred thousand," and sends a man to view the location of the tomb. Placed in the interior of the great church, its base is to measure thirty-six by twenty-four feet; there are to be quadrangular projecting pedestals, with colossal youths chained to the pillars; gods of victory above and emblems of conquered cities beneath; forty statues for the pedestals alone. A second story will sustain a sarcophagus of elaborate form and ornamentation. Eight vast sitting figures on this second story will

be placed over the architectural corners of the lower building. To crown the whole, two angelic forms, bearing the figure of the Pope falling into the sleep of death, are to surmount the structure, which is to be thirty feet in height and adorned with the finest architectural decorations.

Such was the design of Michelangelo, accepted by the Pope; a design which "would require a lifetime to complete and the revenues of an empire." The project was no less indicative of the magnificent ambition of the Pope, than of the bold, aspiring spirit of the designer. It was a Herculean task. Only the most daring mind could conceive and the most skillful hand undertake it.

But the Pope unhesitatingly gave Michelangelo a bill for a thousand ducats and sent him to Carrara, there to quarry the large blocks of marble needed for the work.

Alas for the folly of human ambition and human vanity! Out of the fifty or more heroic figures, planned by the sculptor for the monument, only one was ever finished, although a few others — some blocked out and some nearly completed — have been assigned to the great scheme.

That one, however, — that solitary example of the whole which the mind of the designer had conceived, — is enough to give Julius undying remem-

brance, and Michelangelo a glory never to pass away. For, that single statue, colossal, unique, unrivaled, is his immortal Moses, beyond all comparison the most sublime creation ever chiseled from the marble by the hand of man.

Michelangelo was at work upon it for more than twoscore years, chiseling at intervals, making a smooth surface, the veins of arms and hands and even the thongs of the sandals being minutely wrought. In spite of its present position on the floor in the Church of San Pietro in Vinculi at Rome and its mean surroundings, no one can contemplate its size, its majestic strength, its stern, unyielding countenance, without feeling in some measure the awfulness of the ideal being which the artist intended to portray.

We say "ideal being," for it is no real personage, not even the ancient lawgiver whose name it bears. It surpasses in grandeur not only the foremost man of the epoch in which it was conceived, but also the foremost man of any era of the earth's history. The sculptor determined to reveal in that heroic brow, in that flowing beard, that Herculean frame, that terrible glance, and the horns (ancient symbols of strength) protruding from the forehead, the sublime hope of his nation's deliverance from foes temporal and spiritual.

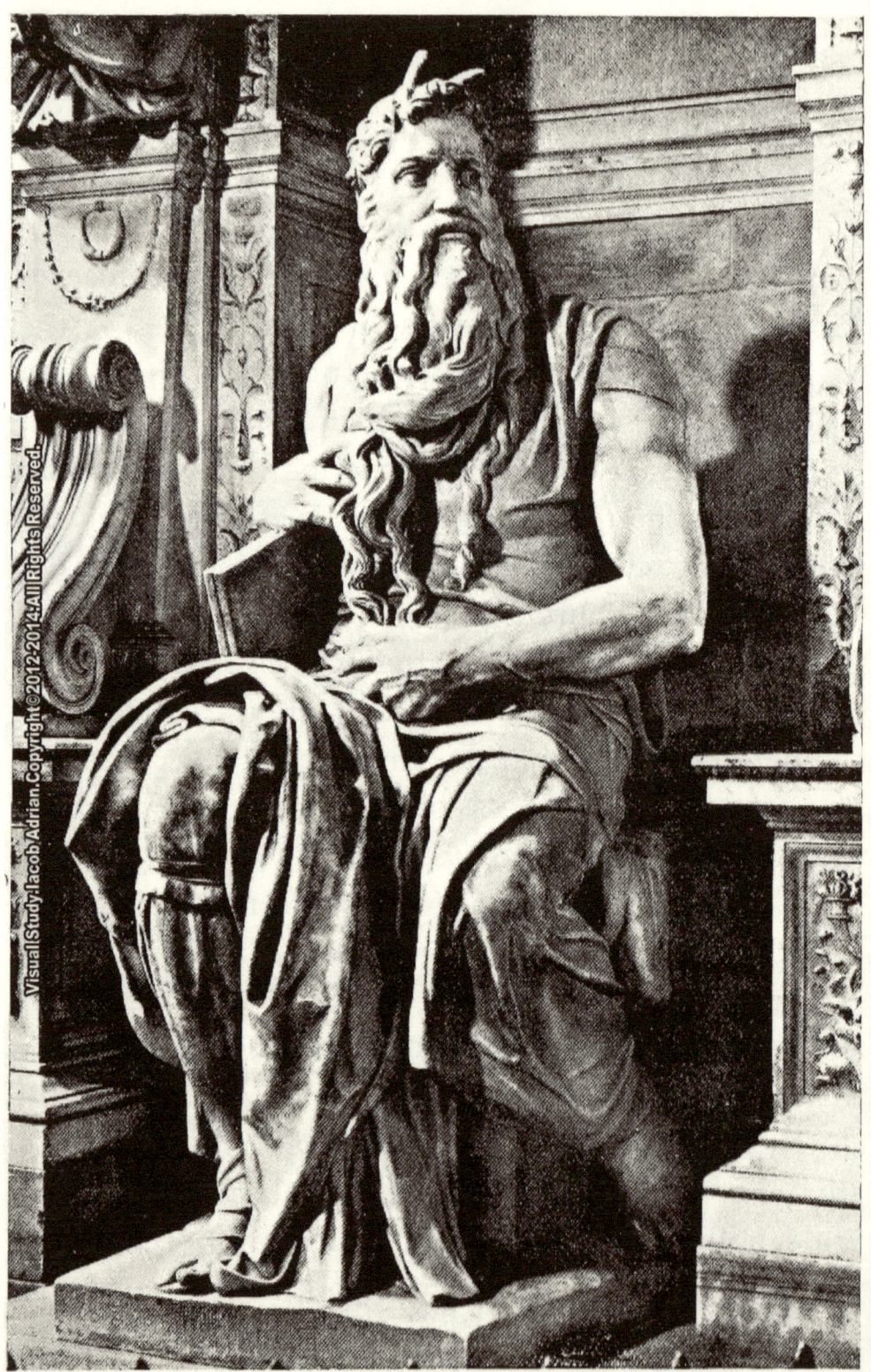

Notes

The times were full of danger to liberty. Italy stood between two powers contending for the empire. Spain and France were rivals. It was supposed that the Pope must become subject to one or the other. Florence was threatened by the exiled Medici; the city had paid Spain 15,000 ducats to buy off an invasion. It was in view of these exigencies that the ardent soul of Michelangelo, filled with yearnings for his country's deliverance, conceived the Moses. So great was his desire for the fulfilment of his dreams, that when the statue was done, he struck it on the knee with his mallet and said to it "Now live!"

The Pope himself may have seemed to Michelangelo to embody something of his ideal, as the sculptor came more and more to understand and appreciate him. An old man when called to the Papal Chair, Julius II. conquered his feebleness by an exercise of the will, and he delivered Italy from tyrants at home and abroad. He had no idea of surrendering to France or Spain. In his day, no monarch could be crowned Emperor at Rome. By statecraft as well as by force of arms, he prevented a catastrophe. Sometimes on one side and then on the other, he fought and excommunicated; he never surrendered, although he occasionally retired from the field, even as he changed his head-

quarters once when a cannon-ball entered the house.

Arriving at last in Rome without an army, ill, and summoned before a Council which certain hostile Cardinals had called, he still projected plans for resistance, gathered a fresh army and took it upon himself to call together a Lateran Council at Rome.

He chose for his watchword, "The Expulsion of the Barbarians from Italy," and this is the meaning of that famous painting by Raffaelle, on the wall of the Vatican, called "The Expulsion of Heliodorus from the Temple."

During a large part of his Pontificate, Florence was under a constitutional government. The family of the Medici made no violent attempts to regain the sovereignty which they had misused. They became politic and bided their time. In spite, however, of the Pope, when Spain invaded Italy and Florence was compelled to pay the 15,000 ducats, the Medici, having asked to return simply as citizens, by the aid of the Spanish garrison seized the supreme command.

This was in 1512; Julius was embarrassed for money, but planned for the expulsion of the Medici and other measures.

He was a born warrior. When Michelangelo

asked him what he should put in the raised hand of his bronze statue at Bologna, the Pope answered "Put a sword: I am no scholar." Fierce and furious when any one opposed his will, by no means scrupulous in morals, he was at all events brave, a lover of freedom, and a noble patron of the arts.

When, therefore, Michelangelo thought of Julius, as he designed and chiseled out his Moses, he must have felt that in the fiery successor of St. Peter were some at least of the characteristics of the great Hebrew leader, whom he portrayed as

"Waiting and clutching his tempestuous beard."

The epic meaning of this masterpiece, then, is not so much religious as patriotic. Michelangelo chiseled the Moses for St. Peter's and for Julius' tomb, but mainly as an everlasting symbol of the deliverance which Italy might expect and which sometime would be wrought out.

Into this statue he put the might of a Titanic force in reserve for the emergency, that his countrymen, yea! that all the world might recognize a power in the heavens above, giving to men imperious courage and persistency.

The Moses is a great leader and commander, seated calmly for the moment in significant repose, as if awaiting the fullness of time. When events,

in God's providence and the inspired voice of a united people, shall call him to arise, then must he, arousing himself and shaking his locks, go forth to conquer in Jehovah's name.

As we gaze at those stupendous limbs and into that stern eye, it seems as if the powerful arms must quickly raise themselves aloft, as Moses lifted his hands with the rod over the field of Rephidim, when Israel fought with the Amalekites and prevailed.

III.

THE SISTINE CEILING.

Julius II. was destined to see neither the completion of his mausoleum nor the fulfilment of his wish for the freedom of Italy. Before the Moses was ready to be exposed to popular view, he became indifferent to the building of the tomb, and in 1508 commanded the sculptor, much to his disgust, to leave the statue and begin another work which promised a speedier completion. The Pope insisted that Michelangelo should paint the immense vault or ceiling of the chapel built by Sixtus in 1473. The artist resisted, but Julius was obstinate.

Unlike in many characteristics, these two men were in perfect accord in seeking the restoration of freedom to the whole of Italy. Their similarity also in a sort of fiery independence is no less remarkable.

What strange times they must have had together! The Pope refused the sculptor an audience on one occasion, and so the sculptor

gathered up his effects and went off to Florence, only to be brought back after repeated solicitation and then under a safeguard as ambassador from Florence. Julius might even have made war with the Signory to get the artist back; therefore they pleaded with him to return.

Julius knew the value of his acquisition, and when, after another quarrel, a Cardinal ventured to excuse Michelangelo by saying "These artists never know how to behave," the Pope turned on him, and, berating him soundly, exclaimed, "Do you dare to say to this man things I would not say to him myself? Out of my sight with your awkwardness!"

Sometimes one yielded and sometimes the other; but the result was always a mutual recognition of the independent persistency of each other. Once (in 1510), because of an angry word, the Pope struck the sculptor with his stick, and again Michelangelo went home and prepared to leave. This was the man whom Pope Clement VII. did not ask to take off his hat in his presence, for fear that he would immediately put it on again; and he always asked him to sit down, lest Michelangelo should sit without being asked.

When it was decided that the ceiling of the Sistine Chapel should be frescoed, six painters

The Sistine Ceiling.

of ability were summoned from Florence to assist the artist. He soon found them useless, and one day they found the chapel closed and their master absent. There was nothing for them to do but to set out quietly and return to Florence. Michelangelo could not bring himself to the point of telling them to leave.

After this, on the scaffolding which he invented and which was a marvel of mechanical skill, the great artist lay on his back, one hundred feet above the floor, in the unwholesome atmosphere close by the ceiling, and for twenty months worked away, communing only with his own thoughts. A color-grinder and the Pope were the sole persons allowed upon the scaffolding. At the end of a period of ten months, one-half of the ceiling was nearly completed and the Pope insisted on taking down the staging.

The artist resisted, but Julius was inexorable and asked in a passion, "When will you come to an end?" "When I can," replied Michelangelo. Then the Pope thundered out, "You want me to have you thrown off the scaffold, do you?" and the artist knew he must yield. He suspended his work before it was quite done, and on All Saints' Day, 1509, all Rome poured into the chapel to see the wonderful work.

In ten months more, after incredible labor, fatigue, and vexatious interruptions on the part of the Pope, the whole was exposed to view. The painter had lain on his back so long that to read a scroll or manuscript he must hold it above his head.

At the present time, after the lapse of nearly four centuries, one can hardly imagine the brilliant effect of the colors which time and the smoke of candles have greatly dimmed. And yet the figures still gleam forth in parts like sculptured bas-reliefs hanging from the sky under murky clouds, the boldest existing delineations of the most transcendent scenes and characters that have ever fascinated and baffled the imagination of man.

The main arch or center of the ceiling, two hundred feet long, displays the historical record of the Book of Genesis. The Almighty appears in realistic proportions, as Creator in the midst of suns and stars, brooding over chaos, sweeping into existence out of nothing the systems which he fashioned by his word.

Man's creation, Eve's appearance, the Relapse from innocence, and the Expulsion from the garden are all delineated in graphic perspective. Cain and Abel offering sacrifices, the Deluge and

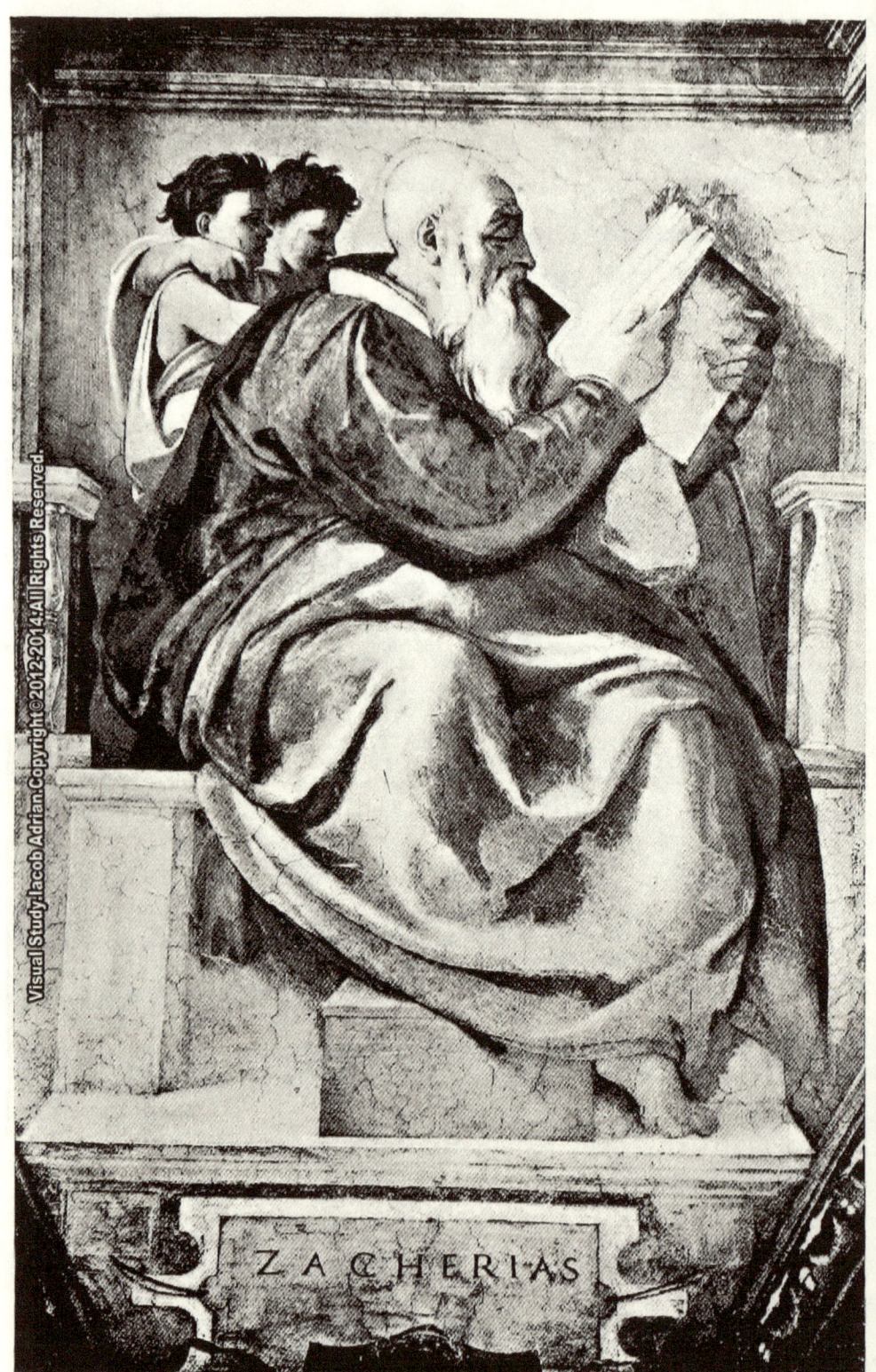

Notes

the Drunkenness of Noah enrich the vast center; the figures superhuman in their strength of limb, and the accessories admirably adapted to the constructive relations of different parts of the various scenes.

In the twelve compartments, set in triangular spaces around the domelike center, twelve gigantic figures appear; figures of Prophet and Sibyl, both of whom the early church considered as inspired to utter oracles and to announce Jehovah's decrees of vengeance or of mercy. In these statuesque creations in fresco, we see what the sculptor would have done in marble, had he been permitted to finish his design for the mausoleum of Julius.

A divine art produced these conceptions; for the artist allowed no dictation, in subject or in treatment, even from the Pope. He sketched and laid on the colors, out of the midst of emotions descending upon his soul in the solitude of his communion with the Infinite, who revealed to him, as in a waking dream, the mighty and mysterious origins of things.

As we contemplate this stupendous achievement, what conclusion is forced upon us, but that the artist intended to impress upon his age the sublime solemnity of life and the prophetic warnings which ever troubled his austere and inexorable soul?

Not yet had he witnessed, even in vision, the

> "Fair and shining cities
> Dropped out like jewels from a broken crown."

Florence was still in possession of its freedom, and the artist had not come into that later period of his creative life, prolific of works in which the master seems to recoil upon himself, then "back upon the world, plunging headlong into darkness."

But even now the prophetic instinct was strong within him, and losing all consciousness of self, penetrating the mysteries of the ages, in dreamy rhapsody while mechanically using the brush, he strove to disencumber himself of the premonitions which oppressed him.

Was he not, as his Zacherias seems to be, striving to pierce the shadows already darkening over his fair land? or may we think that, in an age when Christian Vicars were warriors and the ritual the only relic of the primitive religion, he placed the Delphic, Libyan, and Cumæan Sibyls with the Prophets, to reveal the return to Paganism of the Church of Christ and the Apostles?

Why does his Ezekiel, with body astrain, stretch forth his hand, as if the parchment he unrolled contained the announcement of a coming doom?

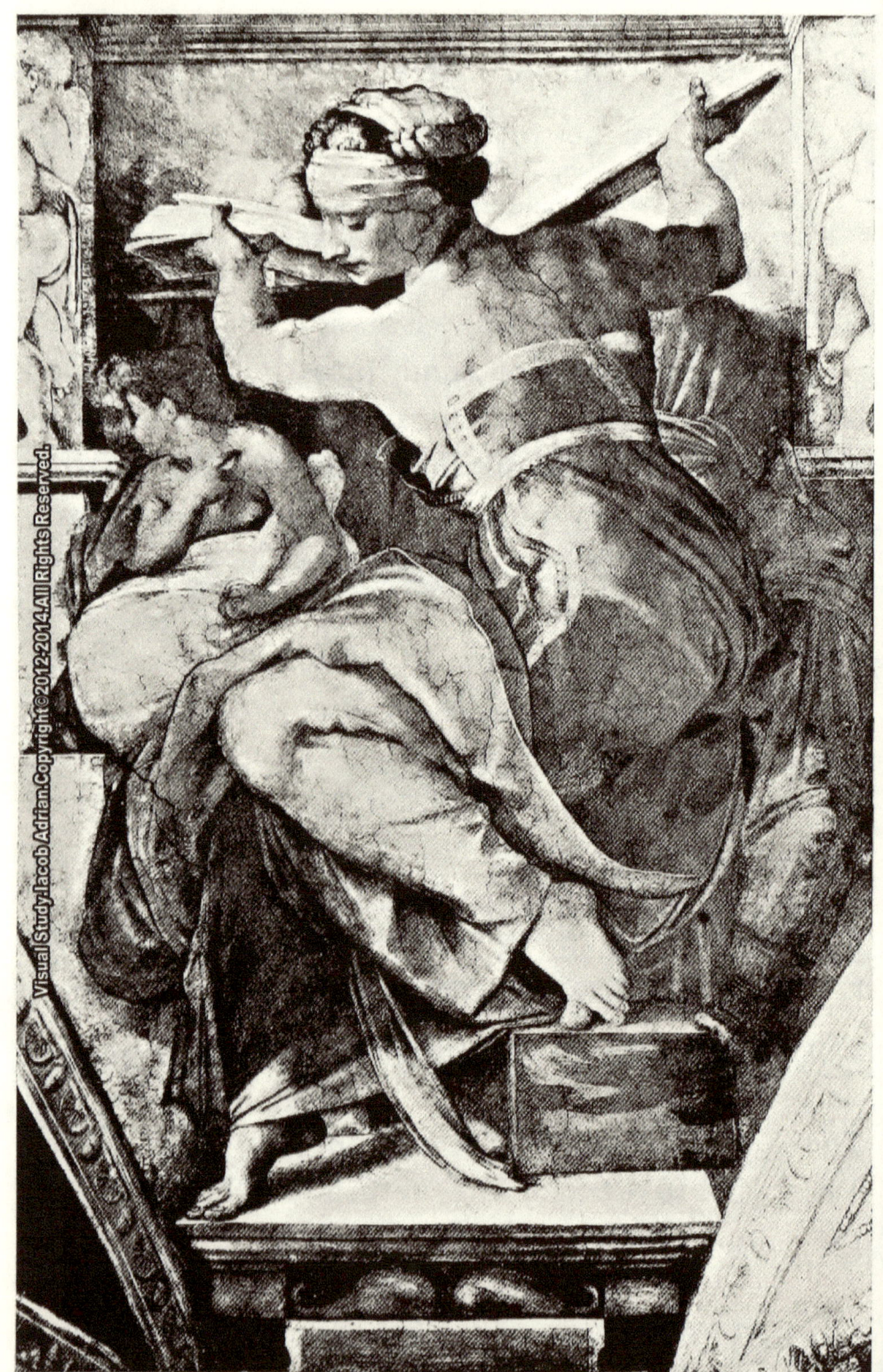

Notes

And why did he place in the four triangles of the corners of the chapel, the Death of Haman, the Serpent in the Wilderness, the Slaying of Goliath of Gath, and Judith with the Head of Holofernes in her hand, if not to symbolize the divine rule of righteousness, with no mercy for the incorrigible?

The religion of that troubled soul was, as we have said, of his times, with little in it of revealing or redeeming grace, and much of the Dantesque conception of immortality. The school of Plato in its finer aspects molded the thought of Michelangelo, more than the tenderness of the school of Christ.

In sonnets, written in his large handwriting still to be seen in the Vatican, his doubts of future happiness rise almost to despair. In his old age he wrote

> "Borne to the utmost brink of life's dark sea,
> Too late thy joys I understand, oh earth!
> How thou dost promise peace which cannot be,
> And that repose, which ever dies at birth.
> For this I know, the greatest bliss on high
> Belongs to him called earliest to die."

Thus the ceiling of the Sistine Chapel marks the end of the second period, during which the artist feared and prophetically announced what afterwards befell him and his unhappy land.

IV.

TOMBS OF THE MEDICI.

WE now approach a group of works, by which we can more clearly interpret the inner life and surcharged heart of the great artist, during the twenty years, in which, for most of the time, two Popes of the family of the Medici ruled in the Papal Seat. The Medicean family, merchants (with three balls on their coat of arms, now used as a symbol by pawnbrokers), rose to power in the fourteenth century, by means of their wealth. Cosmo de' Medici made Florence the central city of Italy. Lorenzo de' Medici, Michelangelo's patron, rose by perilous struggles to the head of the State, humbled the families opposed to him, made himself popular, encouraged the arts, and died leaving three sons, about whom he said that "the first was good, the second clever, and the third a fool." The third was Piero, who succeeded his father in Florence, but was drowned during a battle between the Spaniards and the French.

The second son, Giovanni, a Cardinal at seventeen

years of age, became Pope Leo X. when he was thirty-eight years old, and held that dignity for nine years. The Florentines were proud of the honor, crowded to Rome, and obsequiously kissed the foot of the new pontiff.

Freedom now became impossible to Florence. The Pope aimed to divide the whole land among his relations.

Leo was a man of taste, extravagant, cunning, and desirous of appropriating for himself all the fame that Julius II. had won. Raffaelle was the new Pope's favorite and painted a flattering portrait of the bloated old man with frog-like eyes. Yet Leo gave Michelangelo a commission to cover the façade of the Medicean church of San Lorenzo at Florence with sculptures. It was an immense task, and Michelangelo spent much time in Carrara, getting out the marble. Finally the work on the façade came to a standstill because the Pope was short of funds, and Michelangelo went back to Rome and began again on the mausoleum of Julius, whose heirs still clamored for its completion.

Raffaelle died in 1520, leaving Michelangelo without a rival, but in 1522 Leo X. also died suddenly, and in 1523 another Cardinal de' Medici succeeded him with the title of Pope Clement VII.

Leo had squandered the wealth of three pontificates and died heavily in debt. The rivalry between Charles V. of Spain and Francis I. for the imperial crown, which convulsed Europe for the next thirty years, had begun to disturb Italy, and Clement's pontificate is a history of most terrible scenes.

Nevertheless, the favorite plan of the Medicean family to erect a sacristy, with the tombs of the Medici in it, at Florence, was entrusted to Michelangelo, who began on it at once. The work was completed — that is, it was carried as near completion as we see it now — at the end of the year 1530. The recumbent statues on these Medicean tombs are the most marvelous of all Michelangelo's sculptures except the Moses, and we shall see how the great sculptor wrought into these marbles the very innermost anguish of his soul.

The seven years between the beginning and the end of this great achievement were most eventful. The plague appeared repeatedly at Rome and Florence. The Emperor Charles V. of Spain, having conquered Francis I., crossed the Alps. German and Spanish soldiers, under the Duke of Bourbon, captured Rome. The Pope fled to the castle of San Angelo, and the horrible sack and massacre of 1527 took place under his eyes.

It was at this time that some German soldiers proclaimed Martin Luther Pope, under the eaves of the frowning castle itself. Rome had ninety thousand inhabitants under Leo X. After the sack scarcely thirty thousand poor, famished people remained.

When the tidings of Rome's conquest reached Florence, the citizens drove out the Medici and Jesus Christ was again proclaimed King. It was not Lutheranism but superstitious Catholicism which induced these outward acts of piety.

Michelangelo was in Florence working in the Sacristy. He assisted in restoring liberty to his native city and sat as a member of the Grand Council. In 1529 the very troops who had sacked Rome, Spaniards and Germans, were hired by the Pope and the exiled Medici to attack Florence. It was at this period that iron balls from bronze guns took the place of the old stone missiles from iron barrels.

One Maletesta, a native of Perugia, was made commander by the Florentines to resist the invaders. The city was put in a condition to withstand a siege. War was at the very gates; but a panic seized the citizens, who suspected that Maletesta was a traitor, as finally he proved to be. Many withdrew from the city. Among them was

Michelangelo, who, after warning the authorities in vain, went to Venice, where he lived in retirement till the citizens insisted on his return.

It was still a matter of life and death with Florence. Famine stared the city in the face; but the motto "Poor but free" remained chalked on the house-walls and doors. Michelangelo exerted his strength and skill day and night in fortifying the walls. Occasionally he spent a few hours among his marble figures. While he was fighting the Medici openly, he was secretly working on their monuments. It was because he must work, and these were works already begun. Besides, we shall see why he continued to chisel these statues, even if they were to grace a Medicean tomb.

At last Maletesta turned open traitor and the city, after a most heroic resistance, fell into the enemy's hands. From this time forth, "The soul of Florence is outside the gates: within is but a corpse, corrupted and corrupting." The liberties of Florence henceforth are but a memory and a name.

Michelangelo concealed himself in the bell-tower of a church; he had held his post courageously to the last. The Medici again were masters, but he was too grand a personage to be destroyed. He was allowed to come forth from his hiding-place

and went to work at once on the figures for the monuments in the Sacristy of San Lorenzo. He was treated exceptionally, a privileged veteran: even an Emperor dared not abuse him, and as Pope Julian III. afterwards remarked, when one of his Cardinals opposed the sculptor, "When one Pope dies another is soon made, and I can make a dozen Cardinals; but I cannot make one Michelangelo." The same Pope is also credited with saying that "the sculptor came of noble blood, and for his crest bears two bull's horns, and has given us proof that he can toss with them."

But with what feelings did the baffled, weary, and hopeless man labor on those immortal statues in the Sacristy?

You may see the casts of them, of the same size as the originals, in many a museum of art; but only in Florence itself can you feel the indomitable rebellion in the soul of the artist while he worked upon them.

Each sarcophagus is surmounted by a seated statue of heroic size; one represents Lorenzo de' Medici, who was brave like his father Piero; the other, Giuliano, who was melancholy and wrote a sonnet in defense of suicide. Lorenzo seems like a general listening to the noise of conflict. Giuliano, his uncle, wears a Roman helmet and covers

his mouth with his forefinger, as if in meditation, "brooding over his own doom and the extinction of his race."

Neither of these Dukes was worthy of such mementos. The faces have little resemblance to the originals, but Michelangelo wished simply to express reflection and action, in elevated and impressive forms. He himself confessed the want of likeness, and said "Who in a thousand years will appear, to prove that the Dukes looked otherwise?" They are magnificent ideals, and perhaps the sculptor wished to requite his former patrons, Lorenzo and his brother, by a princely idealization of the family.

A far deeper significance, however, attaches to the four recumbent statues which grace the two sarcophagi, over which the noble Dukes are seated. Whatever Michelangelo wished to represent by the statues of Lorenzo and Giuliano, it was the overflowing and outpouring of his whole soul that produced the Night and Day, the Twilight and Dawn, the marvelous figures which eclipse all sculptured works from other artists' hands.

Passion and despair nerved his arm; he worked with desperate haste; in a few months the figures were as nearly finished as we now see them. Amid the humiliations of his country he executed these

works, which, while they declare the overthrow of liberty, proclaim in unmistakable and ever-enduring forms the agony of his soul, the tumult of his outraged sense of justice, and the stern fate which his presentiments foretold.

These massive figures, one on either side of each sarcophagus, speak of a vast strength rendered powerless; of a grief which can find relief only in the profoundest slumber, and of a superb beauty, half awakened from sleep, with the painful consciousness of a captivity from which there is no release. He might have made more painful groups, like the Laocoön, which he saw exhumed near the Baths of Titus in his early visit to Rome, but it was not pangs that he wished to portray so much as dull hopelessness in view of an inevitable fate.

Michelangelo had already given to Italy a surprise in art. The antique was made by him a vitalizing force in modern naturalism, raising it into idealism. This classical revival was directed towards that lofty and genuine style, from which all true art in modern times has sprung. As Longfellow says:—

> "New learning all! yet fresh from fountains old;
> Hellenic inspiration, pure and deep;
> Strange treasures of Byzantine hoards unrolled."

Here, then, we have this pure, ideal type in its perfection: Of the four recumbent statues, two are men and two are women; or, rather, the pairs are like the angels "which neither marry nor are given in marriage," so heroic are the muscles, and so formidable the limbs.

The Dawn (so-called) is more nearly completed than the others, and despondency is written on her features, as if she dreads to have the light touch her heavy lids. Some dream has destroyed her peace and she is reluctant, even in that half-roused state, to resume life's heavy burden. Could anything express more powerfully the sculptor's passionate weariness of spirit, surrounded by the crushed liberties and expiring hopes of his native land?

He himself gives the clue to this meaning of the statues, in verses written in answer to some stanzas, affixed, according to the custom of the times, to the statue of Night, when it was exhibited for the first time. Those stanzas read:—

> "Night, whom you see slumbering here so charmingly,
> Has been carved in marble by an Angel."
> (A play on the name of the sculptor.)
> "Waken her if you will not believe it,
> And she will speak."

Michelangelo's response was, as if the statue itself replied:—

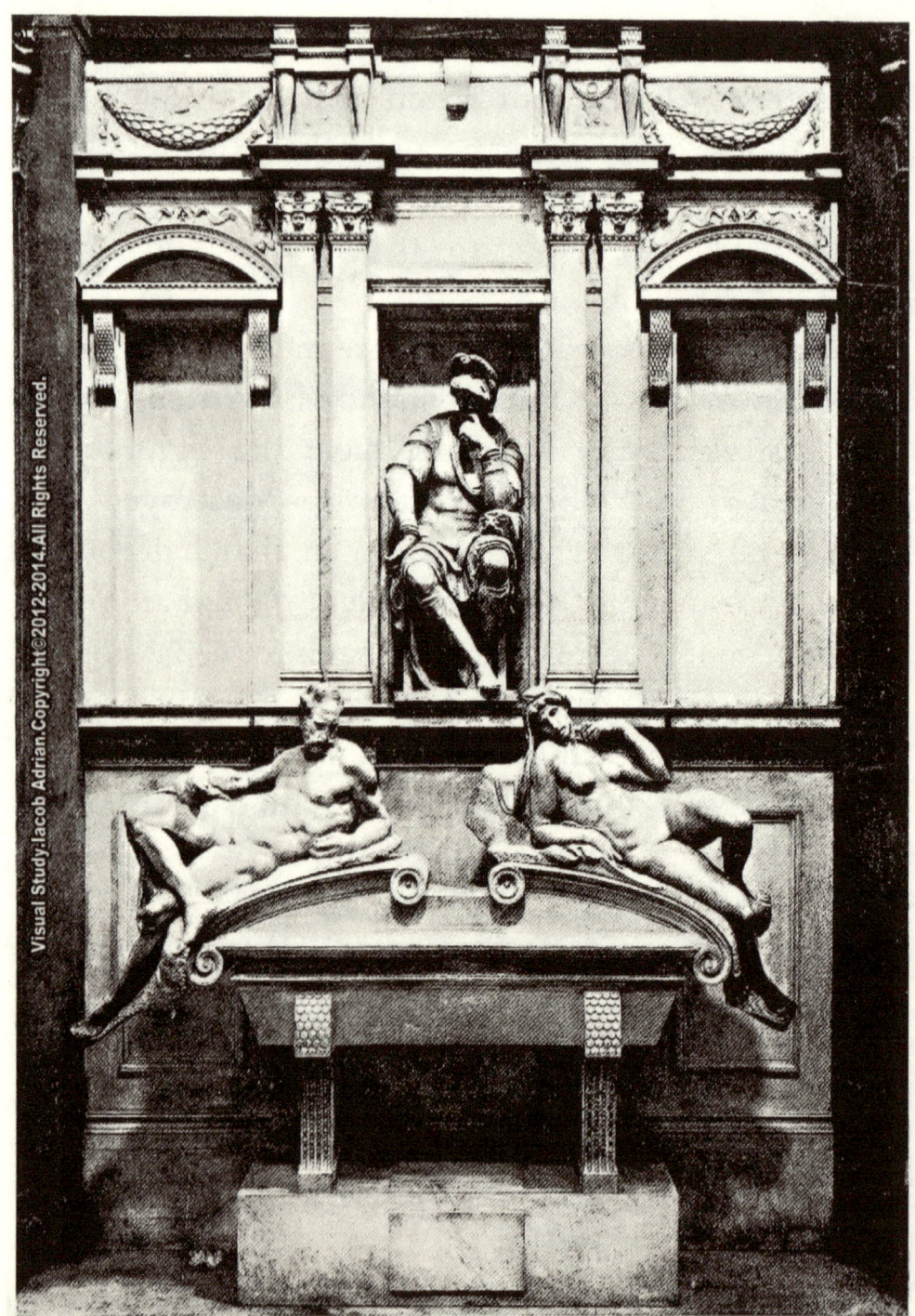

Notes

> "Sleep is dear to me, and still more that I am stone,
> So long as dishonor and shame last among us.
> The happiest fate is to hear and see nothing.
> For this reason waken me not;
> I pray you, speak gently."

Like Samson in his prison house, the mighty artist ground for the Philistines who had conquered; but it was to exhibit before all coming generations the baseness of their conduct, as posterity discovered more and more fully the meaning he had hidden in the stone.

He worked for the ages and not for men; for Fame, for love of his Art; for Justice and for Freedom! His employers were an accident; his creations are immortal! His art was free, and he triumphed even when he seemed to add to the trophies of the conquerors.

Michelangelo was no sycophant, no time-server. He would scorn to purchase even life at the expense of principle. He carved those shrines, not to gain the favor of usurpers, nor for the miserable ducats he received. He had begun the work, as his spiritual lord, the Pope, had commissioned him; in good faith he continues it, but knows that his revenge is sure — that Heaven will see that the tyrants shall receive no honor, but, on the contrary, the everlasting scorn of posterity, by the very means they used to perpetuate their names.

When the sons shall ask their fathers, "What mean these stones?" then the story of the death-blow of freedom at the hand of traitors will be told them and Florence be avenged.

Michelangelo could never fashion the soft and yielding curves, such as ancient sculptors wrought into their goddesses and nymphs. The coarser, harder muscles, which banish thoughts of sex and combine the contradictions of beauty and force, leave even the most undraped of his female figures a modest protection of their own, and suggest less of love than of fear to him who seeks to possess their charms.

This refutes the charge of the fastidious Pope Adrian against the nude figures of the Sistine Chapel. They are not naked, but wrapt in a majestic vitality, compelling lofty thoughts like the Venus de Milo, that noble antique which breathes of power rather than of passion.

Michelangelo was unlike all others. He cannot be judged by ordinary standards. There was but one, there never can be more than one Michelangelo. His moods were fatal to his own happiness, although favorable to his art. His rude vehemence disdained the ordinary conditions of artistic work. He made the marble conform to his ideal; hence his bold contrasts, lofty idealiza-

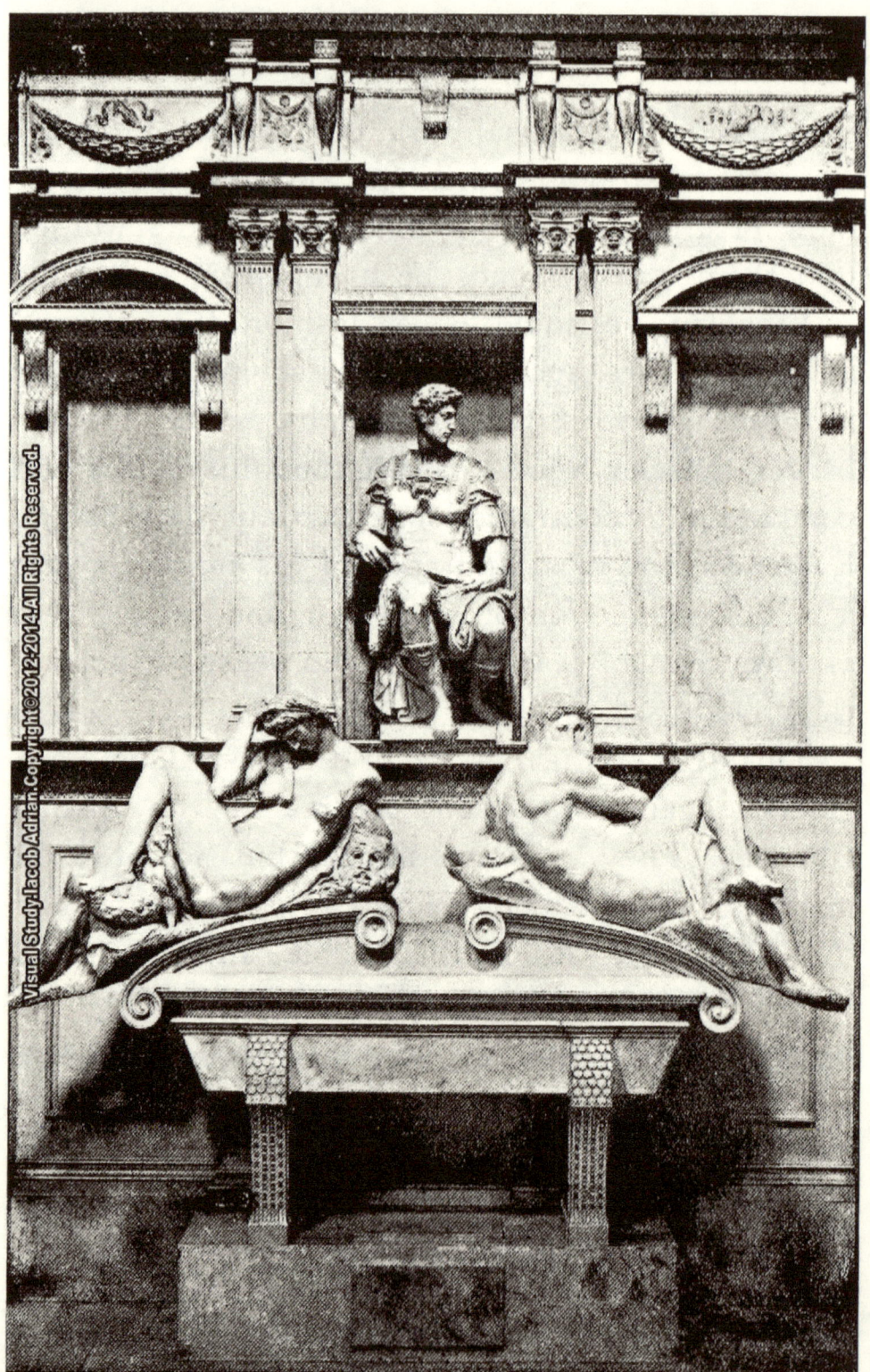

Notes

tions, with occasional departures from conventional symmetries. Inspecting carefully the recumbent statues in the Sacristy, one finds that the block in some places proved insufficient for the heroic size of the human body; therefore, behind the statues are large clefts, as if a portion were broken off. One foot of the male figure, called "The Day," is also too small for the Herculean shoulders and the immensity of muscle.

But if impetuosity aided him in creating marvels in art, it made his life exclusive and melancholy. He began by provoking Torrigiano, a fellow-student, and received a blow which disfigured him for life. With all his competitors in art, except the immortal Raffaelle whom he recognized as his peer, he lived in perpetual antagonism. He had no intimate companions, until in his old age he gathered about him a few young men as his disciples, who hung upon his lips.

He was kind and helpful to his inferiors, but he had a pride in his own conscious power which made him insufferable and overbearing towards those who claimed to be his equals. He was volcanic in his eruptions of temper, although he was often sorry after the mischief had been done. He blustered and then lapsed into quietness, after giving vent to his wrath. Seclusion

became almost a necessity; he cared for no luxuries although he earned large sums. He supported his aged father and the Buonarroti family, even when they criticised his gifts. The softer side of his nature was overgrown with bristling peculiarities; and yet it must be conceded that the softer side was there, for how could an absolutely rude and uncurbed spirit have indited, even to an ideal object, the lines written by the artist: —

"Around that fair and flower-encircled brow,
 How gladly does the golden garland shine;
The proudest bloom is that, which pressing low,
 Leaves the first kiss upon her brow divine."

V.

THE LAST JUDGMENT.

We now pass on to the last masterpiece of Michelangelo that claims our attempt to fathom its epic meaning; it is The Last Judgment, a fresco, painted on the end wall of the Sistine Chapel at Rome, the ceiling of which the artist had already covered with heroic conceptions.

It has been said by a careful critic of Michelangelo's works,[1] that in this fourth period and manner of his art, the great painter resembles Milton, as he appears to us in Paradise Regained, and in his Samson Agonistes. "Both artist and poet," this author declares, "exaggerate the defects of their qualities in their old age," while their "ideals become stereotyped and strained."

Even if this is in a measure true, we do not find that as he grows older there is any marked decline in Michelangelo's enthusiasm, or any servile or degrading obsequiousness to the demand of the times for smooth things. On the contrary, his last

[1] J. A. Symonds, Life of Michelangelo Buonarroti, I. 283.

great fresco is more menacing and tumultuously grand (as we shall soon see) than any of his previous creations.

Michelangelo had returned to Rome never again to set foot in Florence. The "black" Alessandro de' Medici was duke and tyrant over the Florentines, and Paul III., of the Farnese family, was Pope for nineteen years. This pontiff was a man of depraved private and political life, but amiable and generous towards men of learning and ability. He was a firm friend of Michelangelo as long as he lived.

One day he came with his Cardinals into the artist's studio, where the sculptor was still working on the Moses; he looked at the statue and declared that one such alone was a sufficient monument for the mausoleum of Julius; he then insisted on Michelangelo's beginning at once a fresco on the wall of the Sistine Chapel, and that was the origin of The Last Judgment.

Times had greatly changed since the ceiling was painted. A great religious movement throughout Italy was occasioned by Luther's German Reformation. The necessity of reform, in at least the external manners of the clergy, was openly acknowledged; and yet the Church acted towards the Reformation as if it was more a political than

a religious movement. Paul III. sought a reconciliation by gentle means.

Michelangelo was touched by the new movement, not as a thinker, much less as a theologian, but because now in his old age a mighty force had come for the first time into his austere and melancholy life. It was the force, not merely of friendship, but of love!

The "Lion all men feared and none could tame" yielded to the soft influence of a woman! But that woman was no less a personage than the Princess Vittoria Colonna, in every respect worthy of the illustrious friend who laid all at her feet.

He who "braved imperious Popes, more than a King of France would have done," suffered, when he was more than threescore years of age, the pure passion of which he had often dreamed but which he had never before experienced.

From the gnarled old trunk, when it had stood the storms of more than sixty winters, the tender branches shot forth and bore abundant fruit.

It is no common love-story, and yet it is a romance. If it had ended in marriage, it might have lost its interest for us. Some may satirically declare, "If Michelangelo was so morose without a wife, what would he have been with one?" while most women would say, "How could a wife have

possibly lived with *him?*" Thus we are reconciled to the fact as it was, that Michelangelo had no thought of marriage, and Vittoria was vowed to perpetual widowhood. The world would have been distressed had it been otherwise, just as it troubles our sense of fitness to think of the Farnesan Hercules, captivated by Omphale, and spinning flax.

The two friends met, conversed, and parted. The themes they talked about were architecture, the signs of the times, and St. Paul's Epistles. Once it was "justification by faith" (not so bad a subject for a courtship). But the friendship between them, not to call it by a warmer name, was to Michelangelo as holy, and to Vittoria as precious, as harmony in minds and hearts could make it.

Vittoria once gave him a collection of her poems, and he sent her the following lines, which reveal the sweetness which she drew out of the strong, as Samson drew honey from the carcass of the lion: —

> "Not all unworthy of the boundless grace
> Which thou, most noble lady, hast bestowed,
> I fain at first would pay the debt I owed,
> And some small gift for thy acceptance, place.
> (But) well I see, how false it were, to think
> That any work, faded and frail, of mine
> Could emulate the perfect grace of thine.
> A thousand works from mortals like to me
> Can ne'er repay what Heaven has given thee."

When Michelangelo was seventy-two years old, Vittoria Colonna died. He saw her at the last, and was so much affected by her death that he became for a time almost insane. To a friend he confessed, several years after, that he repented of nothing so much as that he had only kissed her hand and not her forehead when he went to her at the last hour.

We mention this episode in the career of the great artist to show how his love for this noble woman affected his religious sentiment and influenced his art. She was one of the intellectual centers in Rome, around which the followers of the reformed ideas gathered. She was suspected by the Inquisition, and in 1541 retired to Viterbo with a few old friends.

If she achieved nothing more, she at least set Michelangelo free from all limitations of the conventional and heartless orthodoxy of the times. Under her influence, he saw the hierarchy as it really was, theatrical even in its devotions. Just as under the power of Dante's works he has reconciled, in his Moses, the Homeric and the Hebrew types, so in his sonnets to Vittoria he has set Plato side by side with the Song of Solomon.

These sonnets are as truly the Songs of Divine

Love for his corrupt times, as the Song of Songs was for the era which produced the Canticles. They are spikenard among rough Styrian rocks. They show this master of great secrets listening to voices we cannot hear, and fathoming the mysteries, of which the common world never gets a glimpse.

When, then, we turn to The Last Judgment, a part of which was executed on the wall of the Sistine Chapel during this period of Michelangelo's intimacy with Vittoria, we have at least a partial clue to the long step in advance of his age, which the painter took when he produced this last great masterpiece.

The walls of many a *Campo Santo*, or churchyard, in Italy were painted, or frescoed, with grotesque and horrible scenes representing the final condemnation of the wicked. The damned were raised from their tombs, to be seized by devils and thrust into the burning pit. All the ingenuity of genius had been suborned to portray the tortures to be inflicted on lost souls. "Heaps of nude flesh — skulls and grinning skeletons — rigid faces — griping hands — staggering limbs" suggested infernal scenes, on which the blessed ones, with Christ above them all, looked down in serene submission or complacent composure.

Even when Rubens tried later to paint The Last Judgment, in his picture now in Munich, he only succeeded (as one has said) in producing the effect of "an immense stream of fishes poured out of a pail," as the naked creatures stream downward into hell.

But The Last Judgment of Michelangelo impresses the mind with a very different emotion; so different that one competent critic has declared that its title should be the "Resurrection," not the "Judgment."

It is true that the Christ appears in it as a stern judge — more of a Jupiter than a Redeemer.

It is true, as Mrs. Stowe has written, that the Virgin Mother seems to hide her eyes from the sight, as if she were the only compassionate being in the picture. It is also true that "the graces of reserve and mystery" are wanting.

But as we think of the religion of the times, the superstition of the people, the cruelty of the Inquisition, the corrupt lives of the Popes and clergy, and the general debasement of the Christian into the Pagan type of the Deity, we cannot help perceiving, even amid the destructive impulses which rule throughout the composition, that the artist has really taken a long stride in advance of all his contemporaries and

predecessors, although far behind our modern thought.

For one sees here, not the torments of hell, but only the dread of them on the faces of those descending into the lower space.

An artist like Botticelli, who shows us the soles of upturned feet in his illustrations of Dante's Inferno, has tried to carry the present material world into Hades, and the porterage has proved too big a load even for his genius. It is imagination run riot; but pandemonium is not power.

Michelangelo may have had in mind the sublime stanzas of his favorite Dante: —

> "Where St. Peter thunders
> In Paradise against degenerate Popes
> And the corruptions of the Church,
> Till all the heaven about him blushes like a sunset,"

but no lurid flames, no exulting fiends, no horrible grimaces, shock us with exhibitions of human grossness under the guise of devilish exaggeration.

To the modern mind the picture is largely anatomical; its foreshortenings surprise one into admiration of the skill of the painter, and the emotion awakened is rather that of astonishment than of awe. Yet Professor W. T. Harris, of the Concord School of Philosophers, keeps the picture over his study table, as a restful object of con-

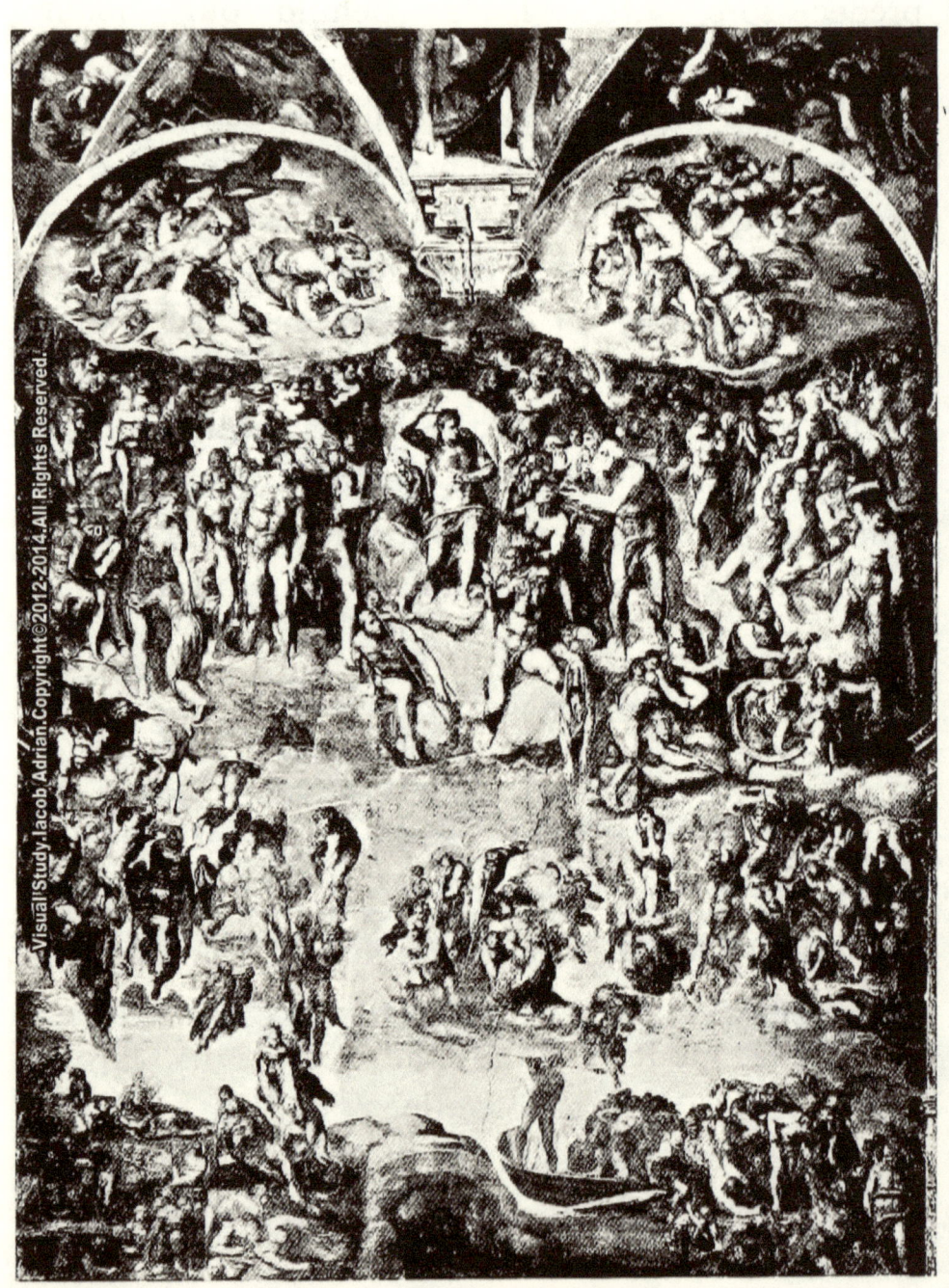

Notes

templation, seeing in the groups of the lost, souls hastening, conscience-stricken, away from the sight of the pierced hands and side of Jesus, but not hurled by his vengeance into the abyss.

There is a touch of Pagan revenge, we must allow, in one corner of the picture, where Michelangelo has placed Signor Biagio (the master of ceremonies who criticised his work) under the semblance of the heathen Minos, judge in Hades, with a large serpent coiled about his body; and Charon is also there, the boatman of the Styx, driving the accursed out of his bark with an oar.

But to the people of the sixteenth century, this pictured dream of the artist's restless and oppressed imagination came like a spectacle of retributive justice, which, as disembodied spirits, they must certainly confront.

They recognized as a true prophecy the struggle of the victims against their well-deserved fate; and they beheld, on the other hand, with equal belief, the saints and martyrs carrying, in proof of victory, the implements and tokens of their sufferings in the service of the Master.

To the Roman populace of that day there was nothing rhetorical or exaggerated in the fresco; those struggling out of the ground were as if actually awakened by the last trump. The whole

scene was terribly tragic, tumultuous, intense, but true to the life. The summons broke over the earth : —

> "Blow, ye bright angels, on your golden trumpets
> To the four corners of the earth, and wake
> The dead to judgment! Ye recording angels,
> Open your books and read! Ye dead, awake!
> Rise from your graves, drowsy and drugged with death!"

The space allotted to the fresco is peopled by a few hundred figures, but in the cloud-tossed, multitudinous composition and arrangement, it seems to contain all the kingdoms, tribes, and peoples of the earth. A sense of largeness, breadth, and universal motion makes the impression of a stupendous upheaval of all nations.

We must remember that books were few and that object lessons were the education of the common people, to whom a work of art like this was the delineation and enforcement of what they believed and feared.

To the crowd that thronged to see the finished painting on that Christmas Day in the year 1541, the marvelous execution and skill displayed in the work may well have been forgotten, as with upturned faces they read what Michelangelo meant that they should read and feel, the wrath of the Almighty when he comes to judge the earth.

It was the painter's last prodigious effort to tell the astonished and terrified nation that the day of retribution must come at last.

No one can study the character of Michelangelo in this work, the somber melancholy, the brooding speculation, the sense of unavenged wrong on earth, the consciousness of the pride, sensuality, infamy, and luxury existing in his times, without perceiving, in this last bitter cry of his dejected soul, a plea for the triumph of good over evil, though a sepulcher of flame receive the transgressors of these shameful years.

The Pope and his Cardinals might quietly take their snuff, as they critically examined the fresco — for what cared they for the Last Great Day in which they practically disbelieved! Paul III. might jest with Signor Biagio's request to have his likeness erased, and say to him, that "Even the High Pontiff cannot release his chamberlain from the pains of Purgatory"; but the people, under the spell of superstitious terror, must have seen the picture with astonished fear.

Going back then four centuries, and sharing with the originator of the work his weariness of the sin which he daily witnessed in that corrupt city of the hierarchy; entering also into sympathy with all the pent-up longings of his soul, we too

must yield assent to the medieval impulse of the painter, and be compelled to acknowledge the high purpose which vindicates "the exaggerated use of sensational foreshortening, and of violent postures of the human body, by which alone the artist's imaginations could be presented to the people of his day."

With one great impulse dominating his art, Michelangelo could not conceive or fashion even the figure of the Christ with any gentle and forgiving presence. He could write beneath his Christ upon the Cross, " Men have forgotten how much blood it cost"; but, as in his Christ standing by his Cross in the Church of Sopra Minerva at Rome, his representations of the much-enduring Son of Man are always muscular, sometimes gigantic, more suggestive of Achilles than of Jesus.

Such being the great sculptor's disposition, impetuous, conscientious according to his light, unable "to condone murder with wax-tapers and Ave Marias," it is the glory of his career that in his four greatest masterpieces he has given art a new vitality, capable of imparting lofty lessons and inspirations to the end of time.

In an age of "servile and degraded obsequiousness" he did not fear to show, in these triumphs

of his genius, his utter scorn of those whom he distrusted and despised. He lived and wrought, like one of the old prophets whom he depicted, under the eye of God, and pointed his countrymen and all the nations to the great white throne and to Him that sat thereon, leaving the gentler message for gentler times, to be proclaimed by those more fitted to make known the Almighty Father's love. Keeping then in view the exalted aims and peculiar surroundings of the great artist, we behold, with Hippolyte Taine, " The disciple of Dante; the friend of Savonarola; the recluse, feeding himself on the menaces of the Old Testament; the patriot; the Stoic; the lover of justice, who bears in his heart the grief of his people and who attends the funeral of Italian liberty (himself alone surviving and exalted amid degraded characters and degenerate minds), passing eight years at this immense work, his soul filled with thoughts of the supreme Judge and listening beforehand to the thunders of the Last Day."

The following year (1542), the Inquisition was established at Rome, under Loyola and Caraffa, the latter of whom became Pope in 1555, under the name of Paul IV.

Michelangelo was made court architect, a position which he held till his death in 1564. St. Peter's Church owes its magnificent dome to his genius, but his life continued a struggle to the end.

He died of old age in his ninetieth year, strange and solitary to the last, without a rival, leaving in his will "His soul to God; his body to the earth and all his worldly possessions to his relatives." But he left no heir to his genius!

Better delineations of the human form in its actual proportions have been given to the world, both in modern and antique art.

Truer interpretations of scriptural scenes and characters have been made by gifted artists; and modern science has enriched art by reconstructing medieval and traditional thought. Yet Michelangelo still stands alone in his supremacy as the greatest modern artist of the world.

It is because his grander works are the result of a unique artistic ability, combined with an intense experience of life's discords, struggles, and vanities.

Something in his work awakens in us a sense of the mystery and sublimity of human destiny, even as the utterances of the old prophets suggested to Israel, Jehovah's infinitude and incomprehensible attributes.

The Last Judgment.

He had begun many other works and his sketches were innumerable; but by the four great masterpieces we have described he will ever live in the remembrance of the generations, as one who, like Moses, struck the rock, perhaps too vehemently, but after whom no mightier leader in art has arisen, to teach the people freedom, righteousness, and the fear of God.

> "So from old chronicles, where sleep in dust
> Names that once filled the world with trumpet tones,
> I build this verse,
> Which to this end, I fashion as I must.
> * * * * * * * *
> Quickened are they that touch the prophet's bones."

Notes

PART SECOND.

MILTON.

———◆———

"Qui legis Amissum Paradisum, grandia magni carmina Miltoni, quid nisi cuncta legis?"—*Samuel Barrow.*

Notes

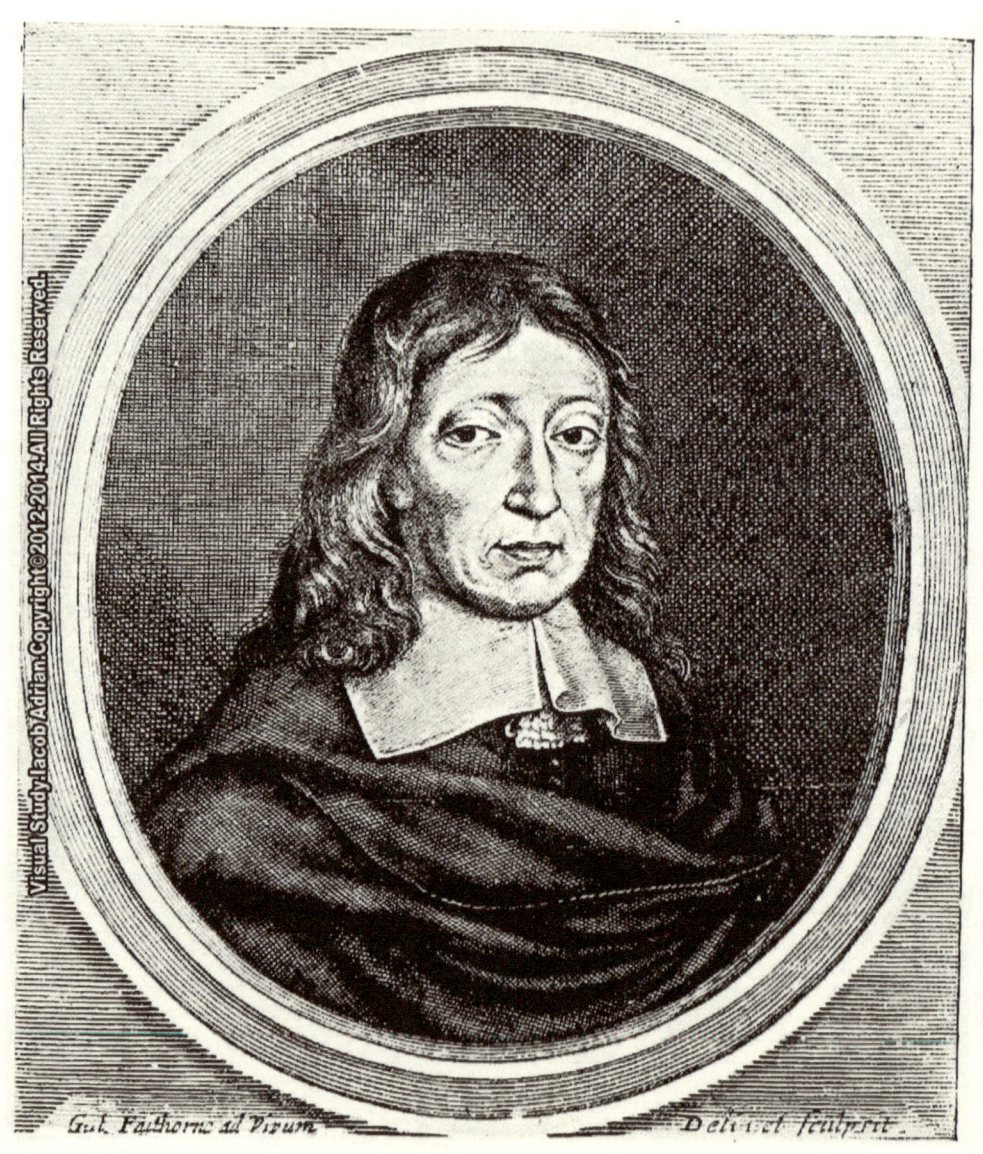

Notes

PREFATORY.

THE transition from Michelangelo to Milton is not great even in the lapse of time, the one passing off the stage in 1564, the life of the other beginning in 1608 and ending in 1675.

A passionate lover of liberty, civil and religious, Milton met Galileo at Arcetri, visited Rome (1638–9), and soon after entered keenly into the political contest in England. As a controversialist his polemical writings in prose won him great renown. He was appointed Secretary to Cromwell, and, gradually becoming blind, heroically devoted the sight that remained to him to the writing of a reply to the Eikon Basilike, a work in favor of the King and the Monarchy. He also wrote A Defence of the People of England.

But his lasting memorial is his great poem, Paradise Lost, the masterpiece of his life, completed in 1665. We select this immortal work in order to show the *Theory of Life* which he has worked out in a masterly style, full of inspiring sentiments and metaphors, and original in its new development of the English tongue.

With Michelangelo, he had his infirmities of temper, and though his Theory of Life, as revealed in Paradise Lost, provokes criticism and dissent, yet as a contribution to English literature the poem will ever rank among the grandest epics in the language.

Like the great sculptor, he was too important a personage to be destroyed, and though his books which were most offensive to the monarchy were burned by the hangman, he was included in the Act of Indemnity and lived to a good old age.

Both Michelangelo and Milton were disappointed in their desire to behold the liberation of their countrymen, and died while the enemy they had fought held possession of the field.

With many points of dissimilarity in character and surroundings, their minds were cast in similar molds. Both boldly invaded the realm of the supernatural, and will live in history among the foremost men of their times, while the whole civilized world will ever honor their genius, their sterling integrity, and their lofty achievements for the exaltation and glory of mankind.

The following pages present the Theory of Life in Paradise Lost, in the light of modern thought.

Prefatory. 97

This is done in the hope of stimulating new interest in a classic which is too often allowed to stand neglected on the library shelf.

To enable the reader to study and to make a still more extended analysis of the poem, the numbers of the books and the lines are appended to the quotations, which are taken from the John Mitford edition.

And as Milton's Adam made bold to ask Raphael to listen to him, so the author ventures to say to *his* " fit audience though few,"

> "Now hear me relate
> My story, which perhaps thou hast not heard;
> How subtly to detain thee I devise,
> Inviting thee to hear while I relate"

what a great genius has written concerning mysteries, about which, since they belong in the realm of the imagination, the more we argue the less we apprehend.

Notes

MILTON.

THEORY OF LIFE AS SEEN IN PARADISE LOST.

I.

THE POET AND THE POEM.

There can be little doubt that Milton as a poet lived in a very different mental sphere from that in which he appeared as a philosopher and a patriot.

The inspiration of his poetic genius led him into realms of the imagination where he breathed his native air. When he descended and wrote for his age and times, he felt the limitations of his epoch and wandered into intricate paths where he halted and stumbled; witness his plea for divorce and some of his devices for a better civil government. Much wisdom, but much folly, marked these lower meanderings. Taking wing as a poet, however, the Cosmos became his empyrean and the universe his expanse of thought.

Necessarily, then, as a poet he was wafted into what with the Greeks was mythological fancy, but with him, poetic symbolism. He must clothe his

ideas in an intelligible garb, and being furnished, by his familiarity with the ancient classics, with heroic models, the sublime altitude of his fancy surrounded him at once with the heroes and exploits of the Homeric age. His unwearied and enthusiastic industry made him early in life a master in classic lore, while at the same time he feasted, as he tells us, on Dante, Petrarch, and all the elder English poets.

The Theory of Life, therefore, which we attempt to extract from his greatest poem, the Paradise Lost, is mainly the supernatural and impassioned side of life, as he beheld it amid the splendors of his own creations and the mighty cataclysms of symbolic fancy.

The poem moves through the celestial part of its majestic verse, with a cadence which Creation might have chosen for its accompaniment, never descending to the jangle and discord of earth-sounds, such as civilization obtrudes into the stillness of primeval forests, or forces upon the plains decked with the roses of Sharon, on the way to the holy city of Judea.

For the terrestrial portion of his song the Homeric poems were also his models; but he swept by them far out into space, and took the heights and depths for his field of action.

We are too civilized, too scientific, to create or enjoy poetic themes like this; we stop too often to analyze statements; we are checked in our progress towards the zenith by instructions of professors; we fold the wings of our fancy under the arc-light of science, and read our Bibles with the historical critics.

Milton read his Scriptures on the mountain top, with eye ranging over the firmament, never stooping to pick up specimens at his feet to confirm his impressions. To us, his angels are "airy nothings," and his archangels, majestic fictions. Our modern skeptic never stands with Milton on the eve of Armageddon, throbbing with expectation mingled with awe; never, in the midst of his conflicts, as a real spectator or participant, thrilled with mystic, nameless exhilaration, as if the supreme moment of Time, the crisis of Fate, had come.

It is a play at which one "assists"; everybody knows that the stage scenery has been set by art and that the actors have no personal existence except in the poet's frenzy. The huge form with dragon wings is no true Satan; only a manufactured counterfeit. You see a real Adam and Eve, because they are man and woman whom you have known under other conditions. But the discomfited angels flounder in a bloodless swamp;

their heavy iron armor ill befits a host of spirits who can feel the pain of wounds but cannot die of them. Satan poses, and so does Ariel.

Only Adam and Eve live and breathe as we mortals do each day, although Adam talks too much like a philosopher for a new-born man, and is too exalted in his conversation for so callow a helpmeet as Eve. No wonder she retired, when Raphael and Adam "girded the sphere" in their discussions and solved the "thwart obliquities." She preferred to be taught by Adam alone, who could "intermix grateful digressions," and "solve high dispute with conjugal caresses." (VIII. 55.)

However, among all the great acts and passions, heroically treated, the thread of a continuous purpose runs and may be followed as a plan of life, a theory of God and a theory of Man, in mutual relationship. We shall attempt to draw out that theory, mainly in Milton's own language.

We do not propose to discuss poetic style or theological dogma, except as incidental to the purpose in hand, or to cite the finest passages in the poem for their own sake; and we will confine ourselves to Paradise Lost as distinct in itself, without adducing other works or poems of the author in confirmation or illustration of the theme.

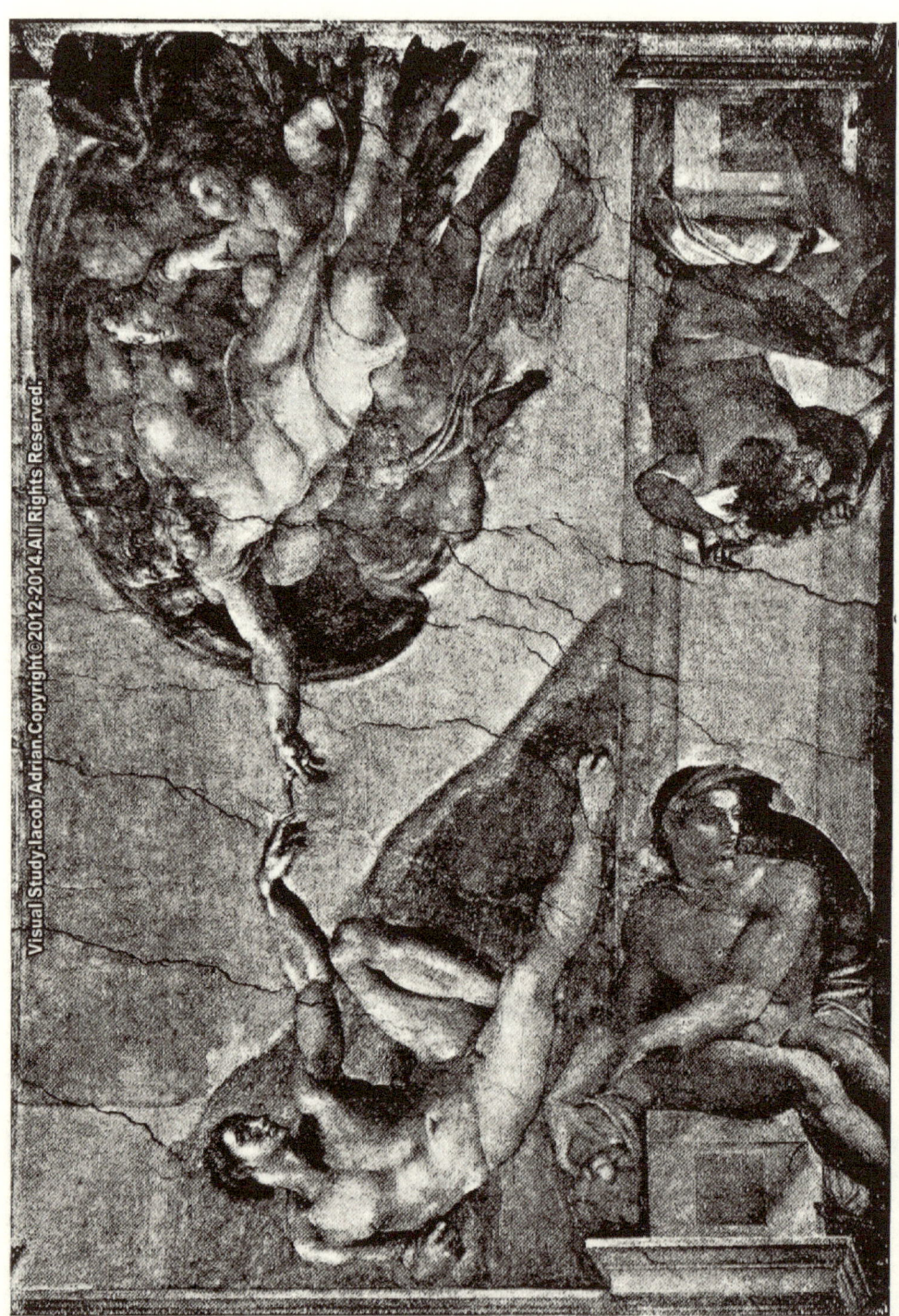

Notes

The general Theory of Life in this poem is as follows: —

Milton represents the Almighty as superior to all, especially in his omniscience and ability to crush the rebellion of his mightiest chiefs. The way He hurls them down to hell, through spaces not then paved with stars, is surpassingly easy, like the story of creation in six days.

Next to God the Father, is the Son, to whom is given the glory of overwhelming the rebellious angels.

Then comes Satan, who is able to repulse the host of loyal angels, until the Son comes upon the scene of conflict and drives the malcontents down to the pit.

Man is inferior in power to Satan, in that being tempted by him, he is overcome. Adam is created a little lower than the angels, including Satan. He can resist and vanquish Satan only by the aid of the Son of God.

Woman is inferior to man. She is more easily overcome by Satan, who knows her inferiority and so assails her first. She can influence man only through his love for her. Adam eats the forbidden fruit because unwilling that Eve should bear the penalty of her weakness alone.

Man and woman are superior to the brutes which they control.

This is the general Miltonic scheme of the life universal. It may be divided into two parts, — that which pertains to the immortals and that which concerns the mortals of God's vast realm.

We will give a brief account, first of the poet's Conception of Superhuman Beings, reserving our more extended *excursus* for the human beings of the poem and their relations, as Milton conceived them, to the grander spiritual existences about them.

II.

CONCEPTION OF SUPERNATURAL BEINGS.

Some one has remarked that "a poet gains influence over his contemporaries by profound sympathy with his generation."

Milton, although he reflected the theology of his times, soared so far above the spiritual ideal of his generation that few read his poems or celebrated his renown.

Thurloe speaks of him as "A blind old man who wrote Latin verses." Richard Baxter passes him over in silence, and he himself, in the Seventh Book of Paradise Lost, states that he has fallen "on evil days and evil tongues," because he stands "far off from the barbarous dissonance of Bacchus and his revelers"; and he invokes the Muse to find for him "fit audience though few."

He was born nine years before Shakspeare died; was blind at forty-four, and obtained for his immortal poem only £10. He died in 1675, in his sixty-seventh year, "without adequate recognition of his genius as a poet, in darkness, poverty, and solitude."

On his solemn and severe theology as a Puritan, tinctured with Arianism, he built a structure too lofty even for his co-religionists. He did not remain a Puritan, and in his later years belonged to no sect. "His views," says his biographer, John Mitford, "appear too exalted, his creed too abstract and imaginative for general use. The religion which he sought was not . . . to be grounded on any settled articles of belief; it was to dwell alone in its holy meditations, within the sanctuary of the adoring heart."

Producing the highest results from the religious ideals of his age, he transformed even the dogmas of the Independents into sublime perceptions, by personifications too subtile, spectacular events too transcendent, and achievements too remote for his countrymen to accept them even as possibilities.

The stars sang together and electric thunders intoned the tragic conflict between God and Satan, in the immense cathedral of the universe, while Englishmen below, upon the pavement of the earth, pursued their avocations and fought their battles, hearing scarcely a note of these celestial symphonies.

But for all that, the poet fastened much of the theology which he thought out for generations of posterity, in a sure place. Like Bunyan's Pilgrim's

Progress in the practical Christian experience, Milton's Paradise Lost fixed in the speculative theology of his times, the ideas that lived and were wrought into creeds for centuries to come.

His Satan (not the Hebrew Satan) became the Satan of the popular mind. His emblematic portraitures of Michael and Raphael were the angelic models which painters reproduced, and which the Church embodied in its hierarchy of heaven.

On what he read out of his Bible, he "piled up pinnacles of diamond, and hewed towers, as from rocks of gold." For eight or nine years, until after Charles II.'s restoration, he brooded over the problem of human destiny, like Michelangelo in the solitude of the Sistine Chapel, till he could stand in the presence of God without bewilderment or fear, and sustain the shock of the Infinite without being consumed by the impact of Divinity.

But his countrymen wanted human passions presented on a lower plane, and while relishing his treatises against Popery and Monarchy, ignored his grandest productions. We of this modern age care little for one or the other. The horrors of Paradise Lost are too refined to affect our nerves; the poet's theories too antiquated to stir our blood.

We quote Milton's familiar lines and ignore the marvelous proportions of his theory of life. We have given up our belief in Satan, who

"Rais'd impious war in Heaven and battle proud" (I. 43),

and hear complacently, the words

"Better to reign in Hell than serve in Heaven" (I. 263),

applied to lesser objects of ambition.

He, who
"above the rest,
In shape and gesture proudly eminent,
Stood like a tower" (I. 589),

is no longer the arch-foe of mankind. We care not

"That riches grow in Hell; that soil may best
Deserve the precious bane" (I. 691);

for we desire them all the same on earth.

And yet, what idea of the Satanic element in human life has been more commonly accepted by the Anglo-Saxon race since Milton's day, than that which he has graphically delineated?

The persistence of Satan, in hating, opposing, and defying the good, almost if not quite equals the perseverance of the Almighty in resisting him. Cast out of heaven, he assembles his legions and nerves them for a renewed onset.

He maintains his courage even when weltering

in tempestuous floods of fire, and says to his second in power, Beelzebub:—

> "Consult . . .
> What reinforcement we may gain from hope;
> If not, what resolution from despair."—I. 187-191.

Escaping the Stygian flood, only to enter the mournful gloom of hell, he is able to cry:—

> "Hail, horrors! hail
> Infernal World! and thou, profoundest Hell,
> Receive thy new possessor."—I. 250.

Then, as if to reassure himself, he adds:—

> "The mind is its own place, and in itself
> Can make a Heaven of Hell, a Hell of Heaven."
> —I. 254.

Again, learning that God has created a new race called man, to take the place of the lost angels, he alone dares the perilous voyage to seek and ruin the new world.

When he spake of war,

> "To confirm his words, outflew
> Millions of flaming swords, drawn from the thighs
> Of mighty Cherubim; the sudden blaze
> Far round illumin'd Hell."—I. 663.

But when it was a solitary journey "through all the coasts of dark destruction,"

> "All sat mute,
> Pondering the danger with deep thoughts."—II. 420.

All but he, who at once "puts on swift wings" and meets the "shock of fighting elements," alone.

He is finally vanquished by force, but Will to Will, Satan against God, the Arch-fiend stands front to front, without submission. It is brute force in which the Almighty is superior, not in strength of will.

This is almost the old Demiurge theory; two supreme powers contending for the mastery of the universe; good against evil, with much suspense and apparent uncertainty as to which of the two shall win at last.

When God the Father saw Satan in rebellion, leading banded multitudes to oppose the armies of heaven, he said to the Son:—

> "Let us advise, and to this hazard draw
> With speed what force is left, and all employ
> In our defense, lest unawares we lose
> This our high place, our sanctuary, our hill."—v. 729.

Add then to this indomitable will-power, Satan's apostrophe, in a somewhat relenting mood, to "Heaven's matchless King," and we can hardly believe that he may not sometime yield to grace and become a reinstated spirit.

Hear him soliloquize as he thinks of his rebellion against his rightful Lord:—

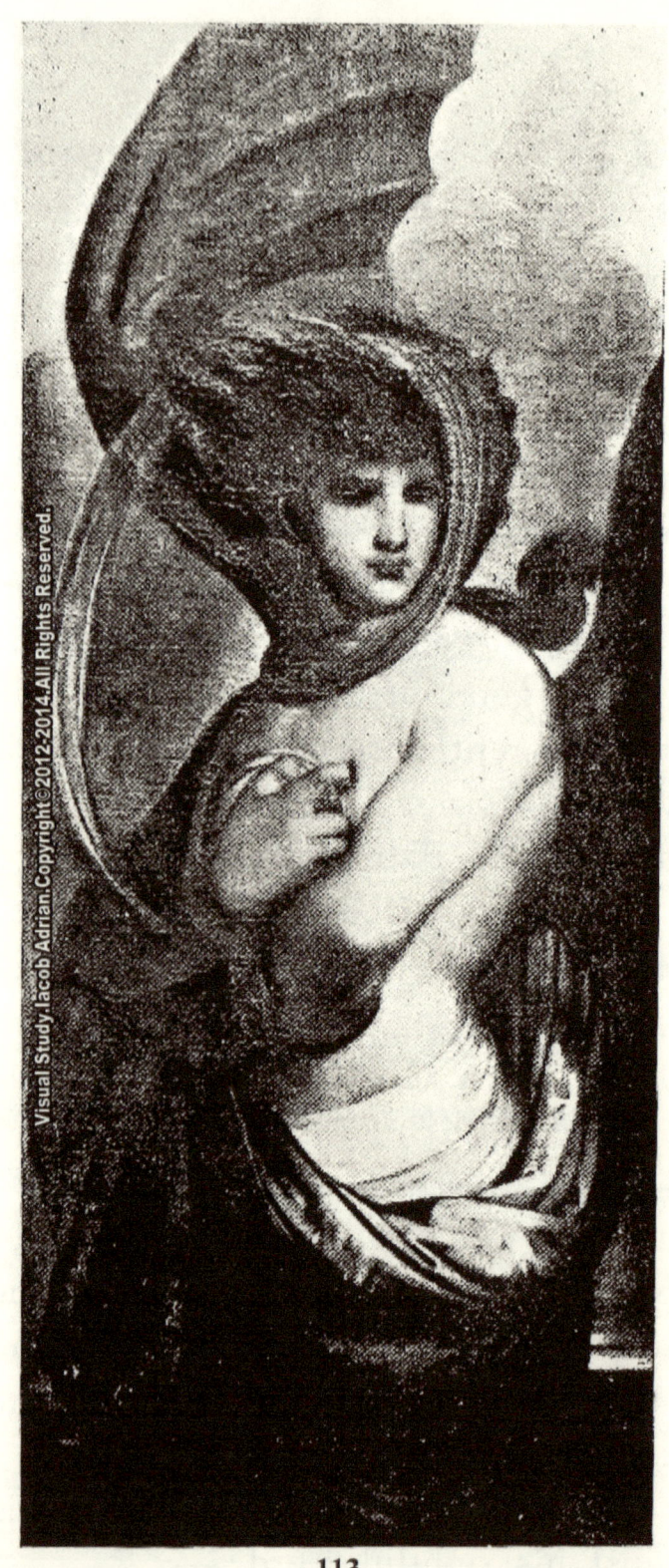

Notes

> "Ah, wherefore? he deserv'd no such return
> From me, whom he created what I was,
> In that bright eminence, and with his good
> Upbraided none; nor was his service hard." — IV. 42.

He alights on the orb of the sun, in his journey to the earth; Milton's description lingers almost lovingly on the picture: —

> "And now a stripling cherub he appears,
> Not of the prime, yet such as in his face
> Youth smil'd celestial, and to every limb
> Suitable grace diffus'd, so well he feign'd;
> Under a coronet his flowing hair
> In curls on either cheek, play'd; wings he wore
> Of many a colour'd plume, sprinkled with gold." — III. 636.

Hear also his soliloquy as he approaches and gazes upon the innocent beings, whom he calls a "gentle pair," and towards whom he says to himself that he is not hostile: —

> ... "No purpos'd foe
> To you, whom I could pity thus forlorn,
> Though I unpitied. ...
> Honour and empire, with revenge enlarg'd
> By conquering this new world, compels me now
> To do what else, though damn'd, I should abhor."
> — IV. 373-392.

Again remember how, after changing his form to that of a glittering serpent and gliding towards Eve when she was alone, her

> "heavenly form
> Angelic, but more soft and feminine,
> Her graceful innocence, her every air
> Of gesture or least action, over-aw'd
> His malice, and with rapine sweet, bereav'd
> His fierceness of the fierce intent it brought."—IX. 457.

These temporary glimpses of his former state almost compel the mind to disbelieve his exclamation:—

> "All good to me is lost;
> Evil, be thou my good!" (IV. 109),

and so, to accept Milton's own explanation and acknowledge that

> "Neither do the spirits damn'd lose all their virtue,
> Lest bad men should boast their specious deeds on earth."
> —II. 482.

Turning now from Satan, who is undeniably the hero of this epic, to Milton's conception of the Father Almighty, we are obliged to recognize more of a Jupiter on Olympus, holding thunderbolts in his right hand, than of the Father whom the New Testament presents as an object of the highest reverence and love.

This was also Michelangelo's conception, in his Last Judgment, of God as represented in the Christ as Judge.

Without the vices and vulgar indifference to good and evil of the mythological Jove, there is

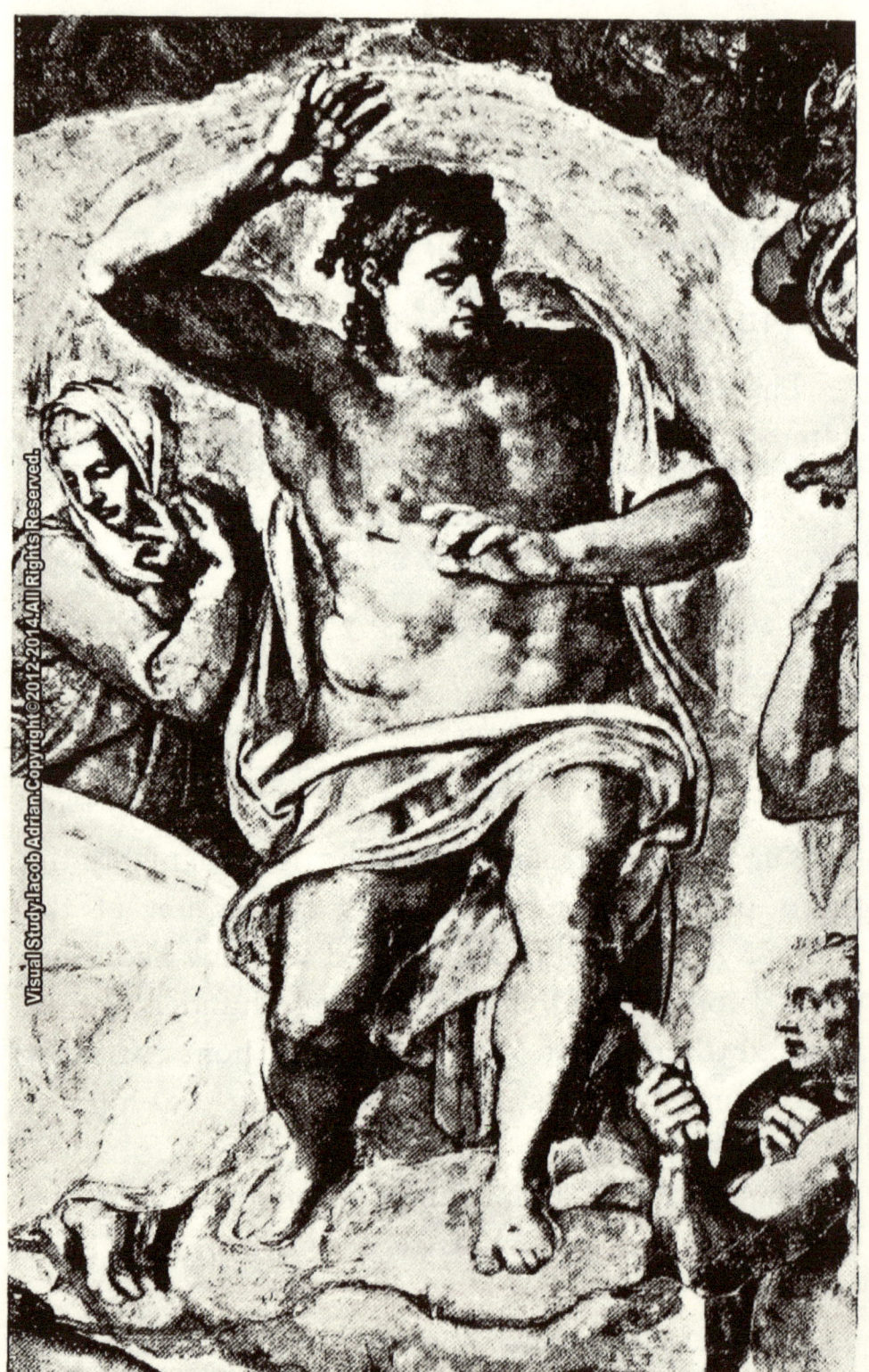

Notes

in Milton's supreme Jehovah so much of wrath, so much of vengeance, and so little of that quality for which the Son is worshiped, that Satan may well have found some excuse for rejecting "grace, on promise of subjection."

We get Milton's idea of the Supreme Being (for it is *his* and not the Bible's) more by what he suggests than by any direct description of the Divine attributes; and the result is by no means satisfactory.

Milton's most remarkable theological tenet is the avowal of what is called the *anthropopathy* of God, attributing to God a Spirit, human passions, and a human form. He says, "If God habitually assigns to himself the members and forms of a man, why should we be afraid of attributing to him what he attributes to himself?" In this, the poet resembles Michelangelo, who had no scruples about representing the Almighty Father, in his frescoes of the Sistine Chapel, as a venerable man, with flowing beard and garments.

Severity, dignity, even visibility for pictorial and poetical purposes, are characteristics which do not disturb us in an exalted poem like Paradise Lost or in the frescoes of the Sistine Chapel, but when God contemplates, with calm complacency, the unbroken, never-ending misery of Satan and a

third part of heaven, we think of a cruel despot, and all that he permits the Son to do, to save tempted and fallen men, goes for little in offsetting his inexorable wrath.

The Almighty Father, seated on his throne, sees Satan flying towards the world to pervert mankind, and reasons thus with the Son concerning the ill-desert of the race, which, yet unborn, is doomed to pay the penalty of its progenitor's disobedience: —

> "Man will hearken to his glozing lies,
> And easily transgress the sole command,
> Sole pledge of his obedience: so will fall
> He and his faithless progeny. Whose fault?
> Whose but his own? Ingrate, he had of me
> All he could have; I made him just and right,
> Sufficient to have stood, though free to fall." — III. 93.

This idea of free-will is often repeated.

The Father relents towards man, because tempted by Satan who he says is self-tempted. Sin, therefore, according to the poet, came into the moral universe, without temptation as an objective motive, and through a spirit or spirits previously innocent, on whom no definite command had been laid. That sort of transgression, by which the angels fell, is without forgiveness.

Man's case is different, and the Almighty declares, in Miltonic phrase, that towards men

"Mercy first and last shall brightest shine." — III. 134.

"Man shall not quite be lost,
But sav'd who will." — III. 173.

Still, man must die,
"unless for him
Some other able, and as willing, pay
The rigid satisfaction, death for death." — III. 210.

To make it harder for the race to maintain its steadfastness, God allows Sin, that monster born of Satan, to build a bridge between hell and earth, over which Sin and Death and all polluting fiends may easily transport themselves at will.

In regard to the Son, his nature, and his relations to the Father and the hosts of fallen spirits, let Milton's own words reveal the poet's thought —

"By merit more than birthright Son of God,
Found worthiest to be so by being good,
Far more than great or high." — III. 309.

"Milton," says Mitford, "denies the eternal filiation of the Son, his self-existence, his co-equality, and co-essentiality with the Father." The Son is "the first of the whole creation, within the limits of Time, endued with the divine nature and substance, but distinct from the Father and

inferior to him. The Holy Ghost is inferior to the Father and the Son. Matter is imperishable and eternal. The body is immortal as the soul."

The Almighty Father said to Adam, when Adam asked for a companion,

> "What think'st thou then of me, and this my state?
> Seem I to thee sufficiently possess'd
> Of happiness, or not? who am alone
> From all eternity; for none I know
> Second to me or like, equal much less."—VIII. 403.

Adam, in the same conversation, declared:—

> "Thou in thy secrecy although alone,
> . . . yet so pleas'd,
> Canst raise thy creature to what height thou wilt
> Of union or communion, deify'd."—VIII. 427-431.

In harmony with this sentiment, before the assembled angels, thrones, and powers, the Father proclaimed:—

> "Hear my decree! . . .
> This day have I begot whom I declare my only Son:
> And on this holy hill, Him have anointed
> Whom ye now behold at my right hand."—V. 602-606.

And what a Son!

> "At his right hand, Victory
> Sat eagle-wing'd; beside him hung his bow
> And quiver, with three-bolted thunder stor'd;
> And from about him fierce effusion roll'd
> Of smoke, and bickering flame, and sparkles dire.
> Attended with ten thousand thousand Saints
> He onward came" (VI. 762);

Conception of Supernatural Beings. 123

> . . . "and into terror chang'd
> His count'nance, too severe to be beheld,
> And full of wrath bent on his enemies." — VI. 824.

"Love your enemies, bless them that curse you," is our only commentary on these lines.

A brief description of Milton's theory of other spiritual beings, and we pass to the theory he has woven into this poem concerning mortals, their relation to the superhuman beings thus described, and their destiny.

To quote again the poet's own words concerning the denizens of the upper sphere: —

> "Spirits that live throughout
> Vital in every part, not as frail man,
> * * * * * * *
> Cannot but by annihilating die;
> Nor in their liquid texture mortal wound
> Receive, no more than can the fluid air.
> All heart they live, all head, all eye, all ear,
> All intellect, all sense; and as they please,
> They limb themselves, and colour, shape, or size
> Assume, as likes them best, condense or rare" (VI. 344-353),

and he has added: —

> "Though what if Earth
> Be but the shadow of Heaven, and things therein
> Each to other like, more than on Earth is thought!" — V. 574.

Old Lucian of Samosata knew as much as this, or pretended that he knew. Possibly Milton bor-

rowed a touch here and there of the "Laughing Syrian Greek," when he wrote, that "shadowy spirits walk the earth invisible."

Lucian gives an account of the "Happy Isles" and their occupants, as follows:—

"Here is a city built wholly of gold. Its wall is of emerald and it has seven gates. There are temples to all the gods built in it of beryl stones. And round about the city flows a river of fragrant oil, more beautiful than can be conceived. There are baths in this city, but in these baths they use not water, but dew. The clothes they wear are of spider web, very fine and of a purple color. They have no bodies, nor flesh, nor can they be touched; yet, though they have the form and semblance only of men, they stand and move and think and speak.

"It seemed to me when I saw them as if it were the bare soul, clothed only with a certain likeness of the body."

When Milton's rebellious angels fought,

> "Their armour help'd their harm, crush'd-in and bruis'd
> Into their substance pent, which wrought them pain
> Implacable, and many a dolorous groan."—VI. 656.

And the worst of their misery was that

> "They needs must last, endless."—VI. 693.

Even the angels and archangels were "with impetuous fury, smote" by "chainèd thunderbolts and hail of iron globes," belched on them by the devilish host.

> "Down they fall
> By thousands, angel on archangel roll'd,
> The sooner for their arms; unarm'd they might
> Have easily as spirits evaded swift
> By quick contraction or remove."—VI. 593.

Spirits also need nourishment

> ... "and food alike those pure
> Intelligential substances require,
> As doth your rational; and both contain
> Within them every lower faculty
> Of sense, whereby they hear, see, smell, touch, taste;
> Tasting concoct, digest, assimilate,
> And corporeal to incorporeal turn."—V. 407.

> "In Heaven the trees
> Of life ambrosial fruitage bear, and vines
> Yield nectar; ... from off the boughs each morn
> We brush mellifluous dews, and find the ground
> Cover'd with pearly grain."—V. 426.

> "Time may come when men
> With Angels may participate, and find
> No inconvenient diet, nor too light fare;
> And from these corporal nutriments perhaps
> Your bodies may at last turn all to spirit."—V. 493.

The truth is, that Milton never attains in this poem to a new idea of spiritual existence. He cannot elucidate heaven nor rise above an earthly

paradise. No ray of his genius pierces the unknown. His entire and marvelous range of simile, figure and metaphor enlarges no human vision of glory or the spirit land.

We come into no intimate relations with the supernatural because of what he has written, except as his lofty periods lift us into the overpowering brightness of the unsearchable, and make the mystery of that other life more intense and ecstatic.

Like Dante, Milton must have his fling at the hooded friars,

> . . . "who, to be sure of Paradise,
> Dying put on the weeds of Dominic,
> Or in Franciscan think to pass disguis'd.
> * * * * * * * * *
> And now Saint Peter at Heav'n's wicket seems
> To wait them with his keys, and now at foot
> Of Heaven's ascent they lift their feet, when lo!
> A violent cross-wind from either coast
> Blows them transverse, ten thousand leagues awry,
> Into the devious air. Then might ye see
> Cowls, hoods, and habits with their wearers, tost
> And flutter'd into rags; then reliques, beads,
> Indulgences, dispenses, pardons, bulls,
> The sport of winds; all these, upwhirl'd aloft,
> Fly o'er the backside of the World far off
> Into a Limbo large and broad, since call'd
> The Paradise of Fools." — III. 478-496.

III.

THEORY OF THE LIFE OF MORTALS.

We turn now to Milton's Theory of Life under mortal conditions, as Adam experienced it after the flaming sword had shut him out of Paradise; "from that day, mortal."

Until that time, he had lived amid

> "Groves whose rich trees wept odorous gums and balm,
> Others whose fruit, burnish'd with golden rind,
> Hung amiable . . .
> . . . and of delicious taste.
> Betwixt them lawns, or level downs, and flocks
> Grazing the tender herb, were interpos'd,
> Or palmy hillock, or the flowery lap
> Of some irriguous valley spread her store,
> Flow'rs of all hue, and without thorn the rose.
> Another side, umbrageous grots and caves
> Of cool recess, o'er which the mantling vine
> Lays forth her purple grape, and gently creeps
> Luxuriant. Meanwhile murmuring waters fall
> Down the slope hills dispers'd, or in a lake,
> That to the fringed bank, with myrtle crown'd,
> Her crystal mirror holds, unite their streams.
> The birds their quire apply; airs, vernal airs,
> Breathing the smell of field and grove, attune

> The trembling leaves, while universal Pan,
> Knit with the Graces and the Hours in dance,
> Led on th' eternal Spring."—IV. 248-268.

After that fatal day,

> "The Sun, as from Thyestean banquet, turn'd
> His course intended; . . .
> These changes in the heavens, though slow, produc'd
> Like change on sea and land, sideral blast,
> Vapour, and mist, and exhalation hot,
> Corrupt and pestilent."—X. 688-695.

Before,

> "Sporting the lion ramp'd, and in his paw
> Dandled the kid; bears, tigers, ounces, pards,
> Gambol'd before them; th' unwieldy elephant,
> To make them mirth, us'd all his might, and wreath'd
> His lithe proboscis."—IV. 343.

Now,

> "Beast . . . with beast 'gan war, and fowl with fowl,
> And fish with fish; to graze the herb all leaving
> Devour'd each other."—X. 710.

> "With delight (Death) snuff'd the smell
> Of mortal change on Earth."—X. 272.

Man himself, who had been born, according to Milton, with high ideas of God's sovereignty, and saying, in his converse with the Infinite,

> "Thou in thyself art perfect, and in thee
> Is no deficience found" (VIII. 415),

now questions his Creator, in terms since used by many of his descendants:—

> "Did I solicit thee
> From darkness to promote me, or here place
> In this delicious garden? . . . unable to perform
> Thy terms too hard, by which I was to hold
> The good I sought not?"—x. 744-752.

This man Adam, who had said "I feel that I am happier than I know," now cries:—

> "How gladly would I meet
> Mortality, my sentence, and be earth
> Insensible! how glad would lay me down
> As in my mother's lap! There I should rest,
> And sleep secure; his dreadful voice no more
> Would thunder in my ears."—x. 775.

Both Adam and Eve, who in Eden,

> "In naked majesty, seem'd lords of all,
> And worthy seem'd; for in their looks divine
> The image of their glorious Maker shone,
> Truth, wisdom, sanctitude severe and pure" (IV. 290),

now came into God's presence, after they had sinned, with hesitating step:—

> "Love was not in their looks, either to God
> Or to each other, but apparent guilt,
> And shame, and perturbation, and despair,
> Anger, and obstinacy, and hate, and guile."—x. 111.

While they remained in Eden, for the

> "Fair couple, link'd in happy, nuptial league" (IV. 339),
> * * * * * * * * *
> "[The] heav'nly choirs the Hymenæan sung" (IV. 711);

For them,
> ... "all Heaven,
> And happy constellations, on that hour
> Shed their selectest influence" (VIII. 511);

> ... "the flowery roof
> Shower'd roses, which the morn repair'd."—IV. 772.

Raphael instructs Adam that this love

> "Refines the thoughts and heart enlarges;"
> * * * * * * * *
> It "is the scale, by which to heavenly love
> Thou may'st ascend."—VIII. 589-592.

But after the transgression a different kind of love was

> "of their mutual guilt the seal,
> The solace of their sin."—IX. 1043.

No longer did they "in honor prefer one another." The man made mean extenuation of his fault, and charged the woman with the blame, "She gave me of the tree, and I did eat"; for they had quarreled.

> "Nor only tears
> Rain'd at their eyes, but high winds worse within
> Began to rise, high passions, anger, hate,

Theory of the Life of Mortals. 131

> Mistrust, suspicion, discord, and shook sore
> Their inward state of mind, calm region once
> And full of peace, now tost and turbulent:
> . . . From thus distemper'd breast,
> Adam, estrang'd in look and alter'd style,
> Speech intermitted thus to Eve renew'd:
> 'Would thou hadst hearken'd to my words, and stay'd
> With me, as I besought thee, when that strange
> Desire of wand'ring, this unhappy morn,
> I know not whence possess'd thee.'" —IX. 1121-1137.

To whom then Eve,

> "'Being as I am, why didst not thou, the head,
> Command me absolutely not to go?
> * * * * * * * * *
> Hadst thou been firm and fix'd in thy dissent,
> Neither had I transgress'd, nor thou with me.'"
> —IX. 1155-1161.

The expulsion and the flaming sword soon follow. In what condition then, were these mortal creatures? What was the world to them, and what the life they now must live?

Scientifically and morally, their lot was hard; for though Adam talked like a philosopher, he had been taught by the Archangel Raphael

> "to live
> The easiest way, nor with perplexing thoughts,
> To interrupt the sweet of life" (VIII. 182),

and all this, after he had been informed by the same high authority that, among other wonders of creation,

> "Out of the ground up-rose,
> As from his lair, the wild beast where he wons
> In forest wild, in thicket, brake, or den
> —Among the trees in pairs they rose, they walk'd—
> The cattle in the fields and meadows green:
> * * * * * * * * *
> The grassy clods now calv'd; now half-appear'd
> The tawny lion, pawing to get free
> His hinder parts, then springs, as broke from bonds,
> And rampant shakes his brinded mane; . . .
> * * * * * * * * *
> . . . the swift stag from underground
> Bore up his branching head; . . .
> * * * * * * * * *
> . . . fleec'd the flocks and bleating rose,
> As plants; ambiguous between sea and land
> The river-horse and scaly crocodile."—VII. 456-474.

Moreover, the poet, although he had visited Galileo at Arcetri and probably had looked through his telescope, made Raphael say to Adam,

> "Whether the Sun, predominant in Heaven,
> Rise on the Earth, or Earth rise on the Sun,
> * * * * * * * * *
> Solicit not thy thoughts with matters hid."—VIII. 160-167.

Under these circumstances and with these commands, Adam, when expelled from Eden, could not solace himself nor occupy his mind with scientific researches. Evolution and its solution of great mysteries was not for him nor for his race. Adam knew more of "devolution," as Froude calls it, than of evolution or its kindred ideas.

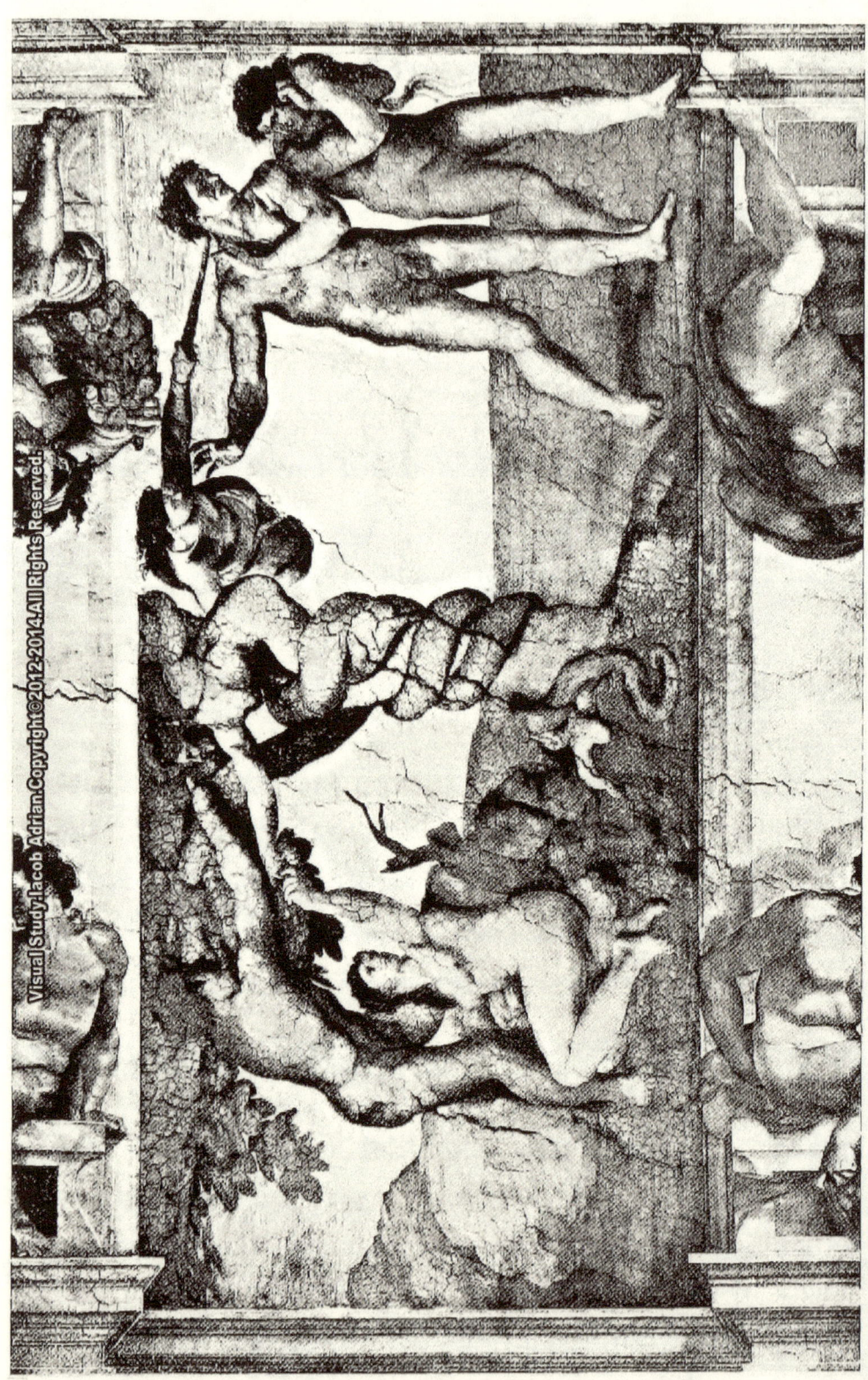

Notes

To be sure, he had some beautiful poetic descriptions to muse upon and brood over; for example, when Chaos heard God's voice, and when the great Creator

> ... "took the golden compasses, prepar'd
> In God's eternal store, to circumscribe
> This Universe, and all created things.
> One foot he center'd, and the other turn'd
> Round through the vast profundity obscure,
> And said: 'Thus far extend, thus far thy bounds,
> This be thy just circumference, O World!'" — VII. 225.

Also the fine passage: —

> "For, of celestial bodies first, the Sun
> A mighty sphere he fram'd, unlightsome first,
> Though of ethereal mold; then form'd the Moon
> Globose, and every magnitude of Stars,
> And sow'd with stars the Heaven, thick as a field." — VII. 354.

He might also regale himself with Raphael's fascinating recital — one of the most exquisite of all the pearls that fell from the archangel's lips — concerning the birds: —

> "From branch to branch the smaller birds with song
> Solac'd the woods, and spread their painted wings,
> Till ev'n; nor then the solemn nightingale
> Ceas'd warbling, but all night tun'd her soft lays.
> Others, on silver lakes and rivers, bath'd
> Their downy breast; the swan, with arched neck
> Between her white wings mantling, proudly rows
> Her state with oary feet." — VII. 433.

He might even allow himself to guess that every star may be "perhaps a world of destined habitation"; for the "Angelic quires," ascending to Jehovah, had voiced this thought as a settled fact, when the "Creation and the six days' acts they sung."

But with this small measure of liberty to speculate, and a false theory of the universe to begin with, what could Adam hold as a theory of life by which to guide his new desire for knowledge, excited by partaking at his wife's request of the forbidden fruit? What ethical basis was there for him to stand upon?

The only moral influence exerted over him in the garden was a false idea of the Almighty and a command to abstain from the fruit of one tree; otherwise, he might follow his native impulses. Adam tells Eve that God is good, but it is not the goodness grounded in the Scriptures as we now understand them.

Neither does any genesis of Genesis land us in such deep perplexity as Milton's Adam must have reached, if, unheeding in his acquired willfulness the archangel's caution, he ventured to extend his search, upon the foundation of the knowledge imparted to him by his heavenly visitant.

Imagine the book of Nature closed to him, and

all the stars and constellations sealed up by the peremptory command that he accept, as scientific enough for all practical purposes, the theory of creation and the universal life which was propounded to him. With such notions of God as Creator, exhibiting his original operations in obvious contradiction to all the laws of Nature which man would soon discover, the race must either repudiate the Deity who thus disclosed himself, or, blindly receiving the Miltonic theory of creation as a mystery, hold itself prepared to accept any theory of God as a moral governor, however contrary that theory may be to its own ethical conceptions of a supreme ruler.

Raphael is sent from heaven to inform Adam that

"Not to Earth are those bright luminaries [the stars] Officious; but to thee, Earth's habitant."—VIII. 98.

Having thus exalted man to the highest place in the new creation, the archangel tells Adam that he has an enemy who will destroy his peace if he can by any artifice; and then gives as a reason why man was created at all, the determination on God's part not to allow Satan to claim that by his defection God has fewer beings to serve and glorify him. His final warning to Adam is, that

"thine, and of all thy sons
The weal or woe in thee is plac'd; beware!"—VIII. 637.

Adam is naturally confused in mind by these and other partial revelations to him of the Infinite Being; therefore, in the midst of dismay and greater perplexity after the fall, he exclaims:—

> "Ah, why should all mankind,
> For one man's fault, thus guiltless be condemn'd?
> If guiltless; but from me what can proceed
> But all corrupt, both mind and will deprav'd
> Not to do only, but to will the same
> With me?" — X. 822.

He would have been all the more confirmed in this Miltonic conception of God's attitude towards man, if he had known of the colloquy between the Eternal Father and the Son, a part of which we have already quoted as taking place when the Father, sitting on his throne, saw Satan flying to the newly created world.

Quoth the Father to the Son concerning the guilt of the angels who fell:—

> "If I foreknew,
> Foreknowledge had no influence on their fault,
> Which had no less prov'd certain unforeknown." — III. 117.

> . . . "they themselves ordain'd their fall." — III. 128.

As for Adam's responsibility for his posterity, God declared:—

> "His crime makes guilty all his sons." — III. 290.

After gaining possession of this preposterous idea, as Adam seems to have done, no wonder that in his mind the unscientific idea of an infinite *creator*, who on the Demiurge theory might fear to be deprived of his supremacy, should reconcile him intellectually to acquiesce in the notion of an unjust *ruler*, who could condemn all the race because of their original progenitor's transgression.

We are, however, greatly surprised when Adam, touched and relenting because of Eve's unhappy plight and her desire for death, suddenly raises

"To better hopes his more attentive mind."—X. 1011.

Calling to mind the mysterious promise that the woman's seed shall bruise the serpent's head, he exclaims, as by a new inspiration:—

> ... "To crush his head
> Would be revenge indeed; which will be lost
> By death brought on ourselves, or childless days
> Resolv'd as thou proposest " (X. 1035);

then, as if recalling something he had forgotten, he bids Eve think of the Almighty, and

> ... "Remember with what mild
> And gracious temper he both heard and judg'd,
> Without wrath or reviling. We expected
> Immediate dissolution, which we thought

Was meant by death that day; when lo! to thee
Pains only in child-bearing were foretold,
And bringing forth, soon recompens'd with joy.
. . . on me the curse aslope
Glanc'd on the ground. With labour I must earn
My bread; what harm? Idleness had been worse."
—X. 1046.

Therefore,

"What better can we do, than to the place
Repairing, where he judg'd us, prostrate fall
Before him reverent, and there confess
Humbly our faults."—X. 1086.

"So spake our Father penitent, nor Eve
Felt less remorse. They forthwith, . . . both confess'd
Humbly, their faults and pardon begg'd, with tears
Watering the ground."—X. 1097.

We must remember that this was before any revelation to Adam of God's mercy through Christ; and the marvel of it all is, that Adam so soon and so suddenly changed his attitude towards the Being whom he had just before conceived of, as creating him and placing him in a most perilous situation, where he would easily disobey and suffer for it, as a predestined end for which he and the race after him were called into existence.

The only harmony in the Miltonic theory lies in the fact, which has been already stated, that an unscientific idea of a creator reconciles the

human mind to any sort of moral arbiter of human destiny.

Such a being is, by virtue of his supremacy alone, outside and above the laws both of Nature and of Justice, as men in their state of partial enlightenment understand these laws!

With Milton's theory in our minds, we may therefore expect Adam, not only to be credulous, docile, and capricious, but weak, irrational, and turned about with every wind of motive. Such a character, whether innocent or guilty, would not harmonize with any Eden.

It may be doubted whether Milton's Adam was ever free, even in the garden and in a so-called state of innocence, since he was handicapped by an arbitrary command, the reason for which he could not apprehend.

The test of freedom is only for a being more or less exalted, who is able to perceive and control all that is involved in the alternative of obedience or disobedience.

In Adam there is, moreover, no heroism of character. He is commonplace, petty, without even the charm of simplicity and freshness, and he seems to be placed under many of the limitations which the Greeks called " Fate."

Such a man would fulfill life's obligations only

under pressure, fear of penalty, or from the desire of enjoyment. How readily he gave up the search for knowledge, to live "the easier way"! In exchange for a sensuous innocence in the garden, he accepted husbandry because he must, and then, for compensation, put aside the grave problems of human life, as a burden of which he was glad enough to rid himself.

He was not a child though often childish, because he used his reason. He was not a savage, solitary among his instincts, because he knew about spiritual beings and something about God. He was simply an egotist, incapable of feeling much beyond his own bodily or mental discomfort. Because it pained him to see Eve sad, he added her sorrows to his own.

If Milton's Deity were on the throne and all the race descendants of Milton's Adam, the only place for them would be the ragged edge of Dante's Inferno, made for "the people dolorous, who have foregone the good of intellect"; or in his Limbo, where is placed a class

"That runneth after good, with measure faulty;
Each one confusedly a good conceives
Wherein the mind may rest, and longeth for it."[1]

[1] Purgatorio, XVII. 126.

Aristotle has said, "The good of the intellect is the highest beatitude," and Dante, in the Convito, "The true is the good of the intellect." But we look in vain in the Paradise Lost for any such instruction from the archangel commissioned to develop the mind of the luckless parent of mankind.

The conditions are changed somewhat when Michael, the other archangel, replaces Raphael in order to show Adam things which will come to pass. Michael is sent to encourage Adam; to explain what the seed of the woman shall be, and how the Paradise he has lost may be regained. This heavenly messenger seems to know far more than Raphael knew, or at least had been permitted to disclose.

He tells Adam of the Son, the woman's holy seed, begotten of God, born of a virgin, the Messiah.

"Thy punishment
He shall endure, by coming in the flesh
To a reproachful life and cursed death;
Proclaiming life to all who shall believe
In his redemption, and that his obedience
Imputed becomes theirs by faith, his merits
To save them, not their own, though legal, works.
* * * * * * * * *
... This godlike act
Annuls thy doom, the death thou shouldst have dy'd."
—XII. 404-428.

Hearing this,
>"our Sire,
>Replete with joy and wonder, thus reply'd:
>'O Goodness infinite, Goodness immense!
>That all this good of evil shall produce,
>And evil turn to good; more wonderful
>Than that which by creation first brought forth
>Light out of darkness!'" — XII. 467.

Then follows the remarkable declaration, which reveals Adam's utter misconception of ethical distinctions: —

>"Full of doubt I stand,
>Whether I should repent me now of sin,
>By me done and occasion'd, or rejoice
>Much more, that much more good thereof shall spring;
>To God more glory, more good-will to men
>From God, and over wrath grace shall abound." — XII. 473.

The effect upon Adam of eating the forbidden fruit seems to have been to confuse not only his intellectual but his ethical perceptions.

Milton, in Book X., gathers the infernal spirits as a host in a grove

>"laden with fair fruit, like that
>Which grew in Paradise, the bait of Eve
>Us'd by the Tempter.... Greedily they pluck'd
>The fruitage, fair to sight, like that which grew
>Near that bituminous lake where Sodom flam'd;
>This, more delusive, not the touch, but taste
>Deceiv'd. They, fondly thinking to allay
>Their appetite with gust, instead of fruit

Chew'd bitter ashes, which th' offended taste
With spattering noise rejected. . . . Thus were they plagu'd;
And worn with famine, long and ceaseless hiss,
Till their lost shape, permitted, they resum'd."—X. 550-574.

Somewhat different were Adam's experiences; but if his increase of knowledge led him to conclusions such as are stated above, we cannot wonder that the fruit of that tree was forbidden. It was surely "bitter ashes" that he chewed, in spite of his hope that "over wrath, grace shall abound."

Michael did not disabuse him of his false notion that sin has in it a prolific power for good. It seems, however, that the angelic hosts were taught better; and why Michael did not illumine his pupil's mind is strange indeed. For when the hosts of heaven were assembled in council, Michael presumably among them, the Almighty had thus addressed them: —

> "O Sons, like one of us Man is become
> To know both good and evil, since his taste
> Of that defended fruit. But let him boast
> His knowledge of good lost and evil got,
> Happier, had it suffic'd him to have known
> Good by itself, and evil not at all."— XI. 84.

It was a great mistake on Milton's part, or an oversight to say the least, to have let Michael miss the opportunity of correcting that fallacy

into which Adam fell; but perhaps the poet, like some theologians, may have really believed what Adam expressed with somewhat of hesitation.

It was a great shock to our first parents to be sent forth from the garden. They, at the news,

"Heart-struck, with chilling gripe of sorrow, stood."—XI. 264.

But the archangel consoled them by touching Adam's eyes with "three drops from the well of life," which gave him the somewhat diluted satisfaction of foreseeing the effects which were to follow his original disobedience.

In these dissolving pictures, Cain and Abel first appear. Cain kills Abel; but Michael says the "bloody fact will be avenged," and the main thing that troubles Adam is, not so much the turpitude of the crime as the first sight he obtains of Death. He is sorry that Cain has slain his brother in anger, and says:—

"Alas, both for the deed and for the cause!"

but, without enlarging on this point, he instantly exclaims:—

"But have I now seen Death? Is this the way
I must return to native dust? O sight
Of terror, foul and ugly to behold,
Horrid to think, how horrible to feel!"—XI. 461.

Upon which Michael gives him his fill of horrors, describing all the diseases to which flesh is heir, over which Death shakes his dart but forbears to strike. This terrible catalogue unmans our first parent, and he gives himself up to tears for a space.

Next comes before his eyes a plain covered with tents, from which issues

> "A bevy of fair women, richly gay
> In gems and wanton dress."—XI. 582.

Adam seems to like this vision, but is soon of his "short joy bereft" as he sees the sons of God yield all their fame ignobly to "the trains and smiles of these fair atheists." Afterwards war follows and the "ensanguin'd field." The flood and other distresses come upon men, till Adam cries out:—

> "O visions ill foreseen! better had I
> Liv'd ignorant of future, so had borne
> My part of evil only, each day's lot
> Enough to bear."—XI. 763.

He revives when he sees the bow in the cloud. He rejoices to see Abraham in his day, also Moses, Aaron, Joshua, and David. He mourns over the Captivity, but when he learns that the Son shall ascend the "throne hereditary," "and

bound his reign with earth's wide bounds," he is with such joy surcharged that he bursts forth in the exultant words: —

> "Now clear I understand
> What oft my steadiest thoughts have search'd in vain —
> Why our great Expectation should be call'd
> The seed of woman!"— XII. 376.

Eve had received her consolation, without the horrors shown to her consort, and awoke well pleased;

> "whereat
> In either hand th' hast'ning Angel caught
> Our ling'ring parents, and to the eastern gate
> Led them direct, and down the cliff as fast
> To the subjected plain; then disappear'd.
> They, looking back, all th' eastern side beheld
> Of Paradise, so late their happy seat,
> Wav'd over by that flaming brand; the gate
> With dreadful faces throng'd and fiery arms.
> Some natural tears they dropp'd, but wip'd them soon;
> The world was all before them, where to choose
> Their place of rest, and Providence their guide.
> They, hand in hand, with wand'ring steps and slow,
> Through Eden took their solitary way."— XII. 636.

Our aim thus far has been to show the theory of terrestrial existence which Adam and Eve consciously or unconsciously must have obtained by their experience, before issuing from Eden upon the "subjected plain."

When they disobeyed and nothing was left for them to expect but death, they said by their actions, "Let us eat and drink, for to-morrow we die." When they found life prolonged, they were somewhat thankful and tried to make the best of their lot; they sought for reasons to content themselves with what was before them.

Eve seems to have discovered that she could be happy anywhere with Adam.

> "Thou to me
> Art all things under Heaven; all places, thou!"—XII. 617.

Adam began to try philosophy, but became confused with the great problems and was thrown into a state bordering on despair. Both Adam and Eve were haunted by "the vision of the virtue they had lost," until Michael's visit to reveal to them future things.

When finally it was revealed to Adam that a chance to regain Paradise was still left, he began to pluck up courage. Then he encouraged Eve, who, of the two, had shown more bravery and had done far more to uphold Adam than he had done to comfort her.

And now, because somewhere in the extremely remote future the seed of the woman would be avenged on the serpent, and the race, after ter-

rible wickedness, apostasy, and misery, would at last be redeemed, both Adam and Eve are represented as scarcely able to contain themselves for joy. They showed, however, but little sympathy for the millions who would sin and suffer horribly, before the blessed end appeared.

Thus Milton's theory of this mortal life, developed in Paradise Lost, is disappointing in its results, as regards human character and destiny.

Where is the love of virtue for its own sake, without reward as an incentive? Where, the yearning after a grand ideal and a noble destiny, irrespective of immediate personal gain or loss? Where, an unselfish motive, except as gleams of it appear in Eve?

Around these two frail, shrinking, erring souls hangs no effulgence from the central orb of glorious being. To them comes no message, by which their humanity is made a part of the divine. Some eloquent passages, like Adam's apostrophe to the Almighty even while the man was innocent, suggest only the Patriarch's covenant, "If thou wilt go with me and keep me, then God shall be my God." We look in vain for the beginnings of immortal, spiritual love.

It is, then, with a feeling akin to sadness that we close the book, without having derived from

this grandest epic ever written in the English tongue, any lofty theory either of this mortal or of the immortal life.

Rich in classical allusion, the author ferries the lost over the Lethean lake, where

> "Medusa with Gorgonian terror guards
> The ford; and of itself, the water flies
> All taste . . . as once it fled
> The lip of Tantalus." — II. 611.

On a single page, he introduces many different characters from ancient mythology, — Proserpine, Ceres, Daphne, Bacchus, and the Libyan Jove.

To arouse Adam and Eve in the morning, the classic Leucothea wakes, and Adam leads Eve to "shadier bower, more sacred and sequestered," than that in which Pan or Sylvanus ever slept, or which Nymph or Faunus ever haunted.

There is also a grim humor in many a passage, as when Belial, in "gamesome mood," sees the angels hit by his iron globes "belch'd from deep-throated engines," and cries out to Satan: —

> "Leader, the terms we sent were terms of weight,
> Of hard contents, and full of force, urg'd home,
> Such as we might perceive amus'd them all,
> And stumbled many. Who receives them right
> Had need from head to foot well understand;
> Not understood, this gift they have besides,
> They show us when our foes walk not upright." — VI. 621.

So when the poet calls Sin, that hag, "foul from the waist downward," Satan's "fair enchanting daughter," we find no lack of the grotesque and humorous, without which no author, even of serious verse, is fully equipped. The grotesque and the horrible intermingle, however, by a strange fellowship, in Milton's personification of Sin and Death, when Sin calls on Death to "feed first on beast and fish and fowl,"

> "Till I, in Man residing, through the race,
> His thoughts, his looks, words, actions, all infect,
> And *season him thy last and sweetest prey.*" — x. 607.

But these are incidentals. Superb, effulgent adumbrations of the Deity abound throughout the poem. There are touches of sentiment, as for example the bliss of Paradise, where our first parents appear to us in all their nuptial beauty and innocence. Exalted thoughts interspersed lift us up to realms of holy meditation; and ambrosial fruit, fit for the gods, hangs over our head.

Yet, after all, the poem as a whole seems classical and cold, and, but for a few warm stanzas, the impression left upon the mind is as if a dead man's hand were placed on the pulse of this throbbing nineteenth century — a relic from medieval crypt — a system of articulated bones,

bedecked with jewels, brought out in vain attempt to cure the spiritual diseases and the moral ills under which earth still groans. We miss especially all holy, humane, exalted nobility of transcendent joy in goodness, mercy, and righteousness, except perhaps in some features of the Messiah, delineated occasionally as the "radiant image" of the new covenant of grace with man.

Like St. Augustine's City of God, or Dante's Inferno, or Michelangelo's Last Judgment, the Paradise Lost of Milton stood in its day for the best religious thought, and so performed its office; but, like some ancient *Credos* which the world finds intolerable to-day, the destined Restorer of the race, as presented in the poem, causes no new heavens and earth to appear, welcomed by choral hallelujahs. Even the Paradise Regained does not compensate us for what is lacking in the Paradise Lost.

It is mainly owing to the times in which Milton lived and wrote, as well as to a certain lack of spiritual perception in himself, that he fails to satisfy us; Government was arbitrary, the people ignorant; neither Cromwell nor the Restoration gave stability to religion, or purity to morals. Among Christians there were endless disputes and animosities.

Add then "the haughtiness of Milton's temper, the fierceness of his scorn, the defiance of his manner, and his severe and stoical pride,"[1] and we see why this epic, written between the vernal and the autumnal equinox of his harassed and painful life, should be "with blind Mæonides," rather than with the sacred muse of the apocalyptic John.

We may at least rejoice that the blind poet, in a manuscript found in 1823 on the shelves of the old State Paper Office in Whitehall, and entitled "Concerning Christian Doctrine," took as his theme the "Book of Sanctity and Virtue"; and that, amid the calmness and dignity of age, with humble and reverential feeling, he wrote, in very different vein, a work not valuable for doctrinal opinions, nor for practical suggestions, but lofty in its aspirations and unquestioned in the fervor of its piety.

While then we of to-day read the poem of the great master, more as a majestic oratorio than as an aid to faith, more as a syllabus of a theory of life incapable of imitation than as a guide to righteous living, nevertheless we may derive from its immortal stanzas, its commemoration of grand though fanciful events, and its vast reach toward

[1] Life of Milton (Preface, ci), J. Mitford.

the infinities, a stimulus and an exaltation, by which

> Beyond "the height of this great argument,
> [We] may assert Eternal Providence,
> And justify the ways of God to men."—I. 24.

IV.

EVE.

THIS sketch of Milton's Theory of Mortal Life would be incomplete without a special study of woman's condition in the world, as the poet conceived it.

His own experience as a husband and a father gives us a clue to his peculiar delineation of Eve in Paradise Lost. In his thirty-fifth year (1643) he married Mary Powell, expecting to find intellectual companionship. He found his bride, as he says, "unfit for conversation," while she soon discovered that spare diet, a choleric husband, a house full of pupils, and no company, did not suit the daughter of a gay cavalier. She thereupon quickly asked permission to visit her father.

Once more in her paternal home, she refused to return; but when her father fell into evil fortune, she came back and begged forgiveness. This Milton granted, and discharged a debt on her father's estate, taking possession of it and also receiving the family into his house after the father's decease.

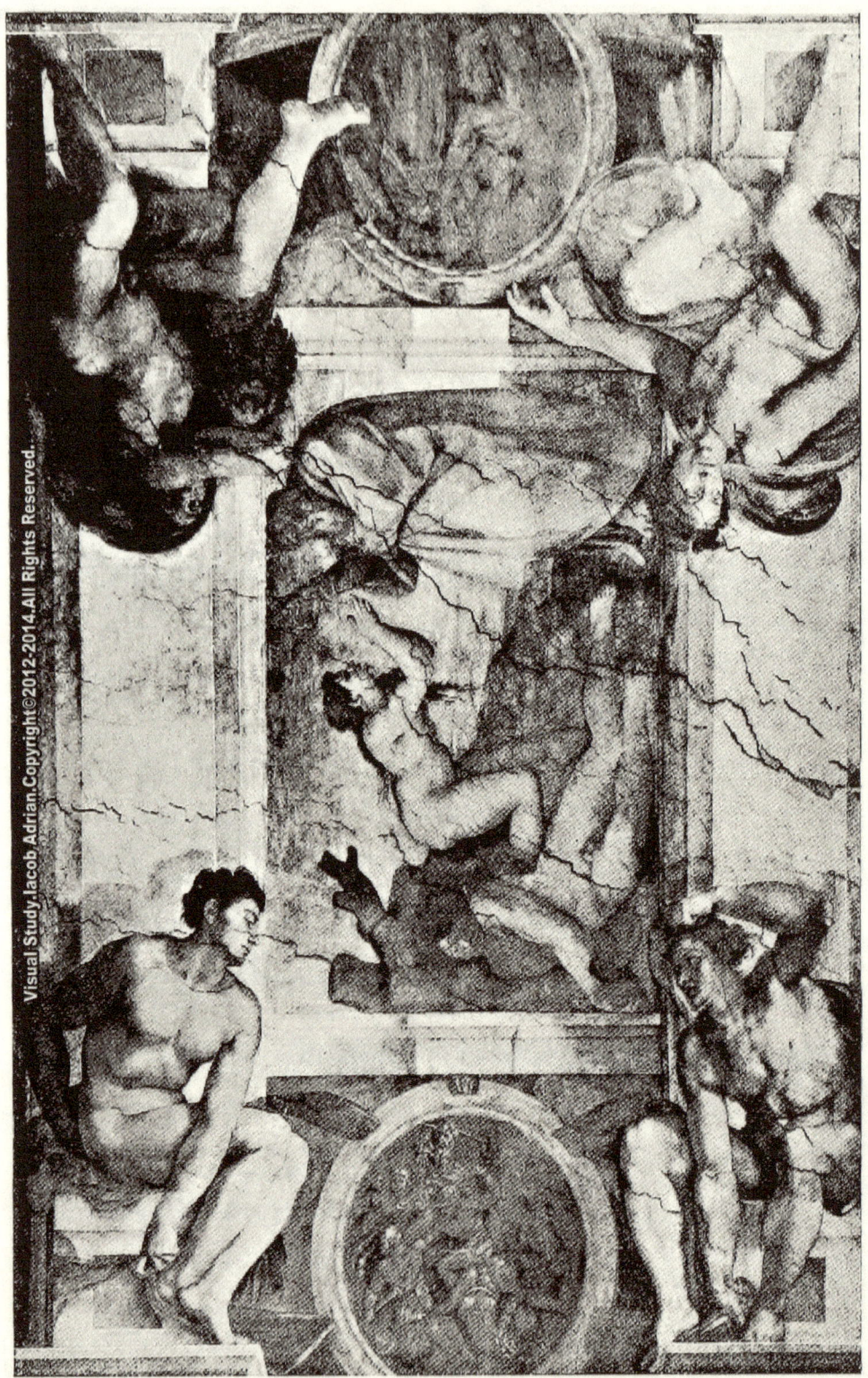

Notes

In 1647 he removed into a smaller house and continued to take pupils, the sons of gentlemen who were his friends. Mary Powell died in 1653, leaving three daughters, one of whom, Anne, was deformed. After being three years a widower, the poet married Miss Woodcock, who died within a year. In 1664 he married his third wife, Elizabeth Minshull, who survived her husband fifty-two years.

Paradise Lost was completed after eight years of labor, in 1665, so that the domestic comfort furnished by Mistress Betty had little to do with the portraiture of Eve. But as neither his first wife nor his daughters gave him much pleasure, his home-life undoubtedly colored his descriptions of the woman in the poem.

He taught his daughters to read foreign languages without understanding the sense, an irksome task for them. He said that "one tongue was enough for a woman"; and yet his daughter Deborah said of him that he was delightful company, being the life of the conversation and of a cheerful, equal temper, at least in his old age. But there is evidence that all the daughters were undutiful and unkind children, careless of him in his blindness and deserting him in his declining years.

In addition to this unfortunate domestic experience, the position of women in England was not, in Milton's day, conducive to the formation of a high estimate either of their capacity or their just rights. According to the old English theory, a woman was a chattel, all of whose property belonged to her husband. He could beat her as he might a beast of burden, and the law gave no redress. It was not till 1790 that a law was passed allowing women to be hanged, like men, instead of being burned when sentenced to death.

It is true that six hundred years ago abbesses, equally with male ecclesiastical dignitaries, were summoned to sit in Parliament; and in the time of Charles II. the ownership of a borough occasionally devolved upon a woman; the right of a woman to succeed to the crown was also unquestioned. But these prerogatives of women pertained to an ecclesiastical and monarchical system, which Milton abhorred, and at best the place for women was but a narrow one, made larger when gained, only by exceptional qualities of a masculine sort in the feminine occupant.

Taking these things into consideration, we must give the poet due credit for allowing Adam to describe his consort as a creature —

> "so lovely fair,
> That what seem'd fair in all the world seem'd now
> Mean, or in her summ'd up, in her contain'd.
> * * * * * * * * *
> Grace was in all her steps, Heaven in her eye,
> In every gesture dignity and love."—VIII. 472-489.

But the poet is equally decided in giving to Eve inferiority of intellect, which he declares to be "the prime end of Nature." He causes her also to declare that her subjection to man is according to God's ordinance. She to Adam says,

> "My author and disposer, what thou bidd'st
> Unargu'd I obey; so God ordains:
> God is thy law, thou mine; to know no more
> Is woman's happiest knowledge, and her praise."—IV. 635.

On one fatal occasion, however, she seems to have forgotten this humble submission and argued for a division of labor, wishing, as all women do, some time to herself during the day. It takes one hundred and seventy-five lines of the poem to conclude the argument between the pair, in which Eve persists in having the last word, until finally Adam yields to her importunity, and she, withdrawing her hand,

> "like a wood-nymph light,
> Oread or Dryad, or of Delia's train,
> Betook her to the groves, . . . event perverse!"—IX. 386-405.

Never was sweeter picture painted than Milton gives of Eve when Satan found her apart from her anxious spouse.

> "Veil'd in a cloud of fragrance, where she stood,
> Half-spy'd, so thick the roses bushing round
> About her glow'd, oft stooping to support
> Each flow'r of slender stalk, whose head, though gay
> Carnation, purple, azure, or speck'd with gold,
> Hung drooping unsustain'd; them she up-stays
> Gently with myrtle band, mindless the while
> Herself, though fairest unsupported flower,
> From her best prop so far, and storm so nigh."—IX. 425.

The poet then goes on to prove her inferiority and her need of support, by showing how a woman when alone is "opportune to all attempts," first, of flattery, such as Satan poured into Eve's ear, when he approached her in the guise of a glittering serpent:—

> "Fairest resemblance of thy Maker fair!
> Thee all things living gaze on, all things thine
> By gift, and thy celestial beauty adore,
> With ravishment beheld, there best beheld
> Where universally admir'd."—IX. 538.

What woman of average dignity and self-respect would have listened any longer to such a "persuader"!

Then the wily tempter weaves into his flattery the seductive allurement of a new intellectual and

spiritual perception, illustrating the effect of eating the forbidden fruit by the result in his own case.

> "Sated at length, ere long I might perceive
> Strange alteration in me, to degree
> Of reason in my inward powers, and speech
> Wanted not long, though to this shape retain'd.
> Thenceforth to speculations high or deep
> I turn'd my thoughts, and with capacious mind
> Consider'd all things visible in Heaven,
> Or earth, or middle, all things fair and good.
> But all that fair and good in thy divine
> Semblance, and in thy beauty's heavenly ray,
> United I beheld; no fair to thine
> Equivalent or second! which compell'd
> Me thus, though importune perhaps, to come
> And gaze, and worship thee of right declar'd
> Sov'reign of creatures, universal Dame!"—IX. 598.

Curiosity and desire then urge Eve to say quickly,

> "Where grows the tree? From hence how far?"—IX. 617.

> "To whom the wily Adder, blithe and glad,
> 'Empress, the way is ready and not long.'"—IX. 625.

"Lead, then," Eve replies, surprised that he leads her to the Tree of Knowledge. The serpent's specious reasoning that life more perfect will be attained by eating, since he has eaten and lives in a wider sphere of intelligence,

> "Into her heart too easy entrance won,"

and so she plucks and eats.

Adam, when he hears of the fatal trespass, is at first speechless; then he chides her; afterwards, submitting to what seems remediless, he seeks arguments no less fallacious than those by which the woman had been deluded:—

> "Perhaps thou shalt not die; perhaps the fact
> Is not so heinous now, foretasted fruit,
> Profan'd first by the serpent, by him first
> Made common, and unhallow'd, ere our taste:
> Nor yet on him found deadly; he yet lives;
> Lives, as thou saidst, and gains to live, as man,
> Higher degree of life: . . .
> Nor can I think that God, Creator wise,
> Though threat'ning, will in earnest so destroy
> Us, his prime creatures, dignify'd so high,
> Set over all his works; which, in our fall,
> For us created, needs with us must fail."—IX. 928-942.

And then, overcome by his love and the sight of Eve's distress, he settles the question by exclaiming,

> "However, I with thee have fix'd my lot,
> . . . if death
> Consort with thee, death is to me as life."—IX. 952.

Thus fondly overcome, he scruples not to eat, and then

> "As with new wine intoxicated both,
> They swim in mirth, and fancy that they feel
> Divinity within them breeding wings,
> Wherewith to scorn the earth."—IX. 1008.

A little after, having quarreled, Adam concludes their mutual accusation, by saying:—

> "Thus it shall befall
> Him who, to worth in women overtrusting,
> Lets her will rule; restraint she will not brook,
> And, left to herself, if evil thence ensue,
> She first his weak indulgence will accuse."—IX. 1182.

But this is not the worst. Adam in his despair calls her "a serpent," a rib "crooked by nature" (X. 884), and "that bad woman." He predicts

> "innumerable
> Disturbances on earth thro' female snares
> * * * * * * * *
> . . . which infinite calamity shall cause
> To human life, and household peace confound."—X. 896–908.

> "Oh, why [he cries] did God
> . . . create at last
> This novelty on Earth, this fair defect
> Of Nature?"—X. 890.

We might attribute all this vilification of woman to the bad temper in Adam, which a sense of misery and shame occasioned for the moment, were it not that Milton himself, with calm, deliberate intention, has written of the woman's inferiority and the natural authority over her of man. His words are

> "He for God only: she for God in him.
> His fair, large front and eye sublime, declar'd
> Absolute rule." . . .—IV. 299.

> "She, as a veil down to the slender waist,
> Her unadornèd, golden tresses wore
> Dishevel'd, but in wanton ringlets wav'd
> As the vine curls her tendrils, which implied
> Subjection, but required with gentle sway,
> And by her yielded; by him best receiv'd."—IV. 304.

Milton even makes the archangel advise Adam not to let go, out of deference to woman's beauty, his high conceit of himself.

> "For what admir'st thou? what transports thee so?
> An outside; fair, no doubt, and worthy well
> Thy cherishing, thy honouring, and thy love,
> Not thy subjection. Weigh with her thyself;
> Then value. Oft-times nothing profits more
> Than self-esteem, grounded on just and right,
> Well manag'd."—VIII. 567.

In true accord with this Miltonic theory of woman's subjection to the man, we find Eve (poor mother of all daughters of her race!) throwing herself at Adam's feet, in spite of the epithets he had thrown at her, and, with tresses all disordered, humbly embracing and beseeching him for restoration and forgiveness.

> "Forsake me not thus, Adam! witness Heaven
> What love sincere and reverence in my heart
> I bear thee. . . . Thy suppliant
> I beg, and clasp thy knees."—X. 914.

Adam relents towards her, submissive in distress; but when the sentence falls on both, of

expulsion from the garden, neither of them seems to feel their sin so much as its unpleasant consequences. Adam, because life is prolonged, recovers his composure. Eve laments chiefly because she must leave her paradise of sweets.

> "Must I thus leave thee, Paradise?
> * * * * * * *
> How shall we breathe in other air
> Less pure, accustom'd to immortal fruits?" — XI. 269-285.

Michael does not show to Eve the vision of posterity in its vicissitudes of joy and misery; he considers her too weak to bear the sight. Only to Adam does he reveal what shall befall the race derived from him and her. Eve, in her vision deep in sleep, is simply comforted by the promise that in her seed the race shall be restored.

It is very evident from these illustrations, as well as from the whole tenor of the poem, that Milton's Theory of Life included in it the natural inferiority of the woman and her subjection to the man. He makes her more beautiful, more fascinating, but weaker, more open to flattery and specious reasoning. She is perhaps less selfish, but her self-devotion is because man is worthily her head, the crown of her existence and her glory. She deserves less from the Almighty be-

cause sin came into the world first through her transgression. Moreover, according to Milton, she came forth from the great trial not only conquered and overthrown, but a temptress. Woman was made to be a conscience to man, but in Eve she is a dangerous, fascinating, loving, and destructive obstacle to man's integrity.

If she had stood steadfast, Adam might have continued innocent and faultless. Therefore if by nature she is subject to man, much more, because of her sin and its results in her disposition, is that subjection to be continued through all generations.

We do not wonder that Milton, with these views, should have written as he has done on the subject of divorce, which always bears the harder on the woman. Yet, if the structure of human society is to stand or fall by the doctrine concerning woman which is propounded and illustrated in Paradise Lost, then farewell to all hope expressed by Adam of

> "a race
> To fill the Earth, who shall with us extol
> Thy goodness infinite."—IV. 732.

The poet has made Eve to represent what he has adopted as a type of universal womanhood. She is incomplete, as might be expected of the

primeval woman; but unfortunately the fine material in her, by which she might become the complete complement of man, is wanting in Milton's summation of her qualities.

As he delineates her, she is not only inferior to man, but she feels and acknowledges it, and is not ashamed of her inferiority any more than of her unclad beauty. She does not even try to avenge herself for the deficiency decreed to her, by making the most of her fascinating power over Adam to raise him up to a level where she might worthily be subject unto him. If she is chiefly a pleasant companion before the transgression, she is hardly a helpmeet after it, being apparently unconscious that a true woman will not only console her husband in misfortune, but awaken him to renewed virtue and exertion.

In order to quicken his best impulses, she need not urge him to violent measures against Satan who had deceived them and tried to ruin them; but her vehement despair ought not to cause her to say,

"Let us seek death: . . .
Why stand we longer shivering under fears?"—X. 1001-1003.

As a true wife, she was not called upon to taunt her husband with his weaknesses, as the

spouse of the Duc d'Orange taunted hers after his defeat at Roncesvalles.

This haughty woman, looking down from the window of the castle, before which her defeated lord waited for admission, exclaimed: "Thou art not my husband! My husband would return a conqueror, covered with glory and honor. He would not have lived when all those heroes died."

But Eve, at least might have counseled something better than the destruction of them both.

It was generous in her to pray that all the sentence might light on her, as "sole cause of all this woe"; but, confessing this, a model woman, for that very reason, would have tried to put a new heart into her less guilty spouse.

No! Milton's Eve can never stand for the ideal woman of any age, by whose peculiar qualities of mind and heart the family is to be kept pure, the State free from ambition and distraction, and the race progressive in its approach towards final regeneration.

No seed of such a woman, although she may be worthy of cherishing, honoring, and loving, could effectually "bruise the serpent's head," unless some interposition of divine power forced and achieved the victory.

Moreover, the poet's description of Eve proved

false to the very words which he had put into Adam's mouth concerning her, when, before the transgression, the enamoured husband declared,

> "when I approach
> Her loveliness, so absolute she seems
> And in herself complete, so well to know
> Her own, that what she wills to do or say
> Seems wisest, virtuousest, discreetest, best.
> All higher Knowledge in her presence falls,
> Degraded; Wisdom in discourse with her
> Loses discountenanc'd, and like Folly shows;
> Authority and Reason on her wait,
> As one intended first, not after made
> Occasionally; and, to consummate all,
> Greatness of mind and Nobleness their seat
> Build in her loveliest, and create an awe
> About her, as a guard angelic plac'd."—VIII. 546.

In reality, Milton's Eve does not come anywhere near this standard of intelligence or virtue. She proves herself in the event to be as Milton apostrophizes her,

> "O much deceiv'd, much failing, hapless Eve."—IX. 404.

A theory of life with only such women in it would not be terrible to Satan. They might be

> "Fair, divinely fair, fit love for gods" (IX. 489),

but with them as mates, each man might well cry out with Adam:—

> "How shall I behold the face
> Henceforth of God or Angel?
> . . . Oh, might I here
> In solitude live savage, in some glade
> Obscur'd, where highest woods, impenetrable
> To star or sunlight, spread their umbrage, broad
> And brown as evening! Cover me, ye pines;
> Ye cedars, with innumerable boughs,
> Hide me where I may never see them more."—IX. 1080-1090.

Therefore we claim that Milton's Theory of Life, with the woman in it, which he, not the Creator, has brought to man, leaves the world in a worse plight than if no woman had ever been made, to shear man of his strength and leave him "without harmony and true delight."

As Tennyson has written,

> "The woman's cause is man's: They rise or sink
> Together, dwarf'd or godlike, bond or free."

If any one now says, But is not this the Scriptural account of Eve's relations with our great progenitor? we leave the questioner to prove his own implied assertion, being persuaded that he will search in vain to find in Genesis the counterpart of Milton's Eve, as she is pictured in the Paradise she lost.

THE END.

Bibliographic sources :

The masterpieces of Michelangelo and Milton (1896)

Author: Twombly, Alexander S. (Alexander Stevenson), 1832-1907

Publisher: New York, Boston [etc.] Silver, Burdett & company

This documentary study use,
combined in various proportions,
elements from the following categories,
forms and subsets :
- fair use
- documentary
- documentary photography
- feature
- journalism
- arts journalism
- visual journalism
- photojournalism
- celebrity photography
in order to :
- employ material as the object of cultural critique ,
- quote to illustrate an argument or point ,
- use material in historical sequence,
providing independent opinion,
using photos, press articles, advertisements,
opinions of fans etc. ...

Copyright©2012-2014 Iacob Adrian
All Rights Reserved.

www.ingramcontent.com/pod-product-compliance
Lightning Source LLC
Chambersburg PA
CBHW031051180526
45163CB00002BA/786